Richard Smith
Seven Exhibitions
1961 – 75

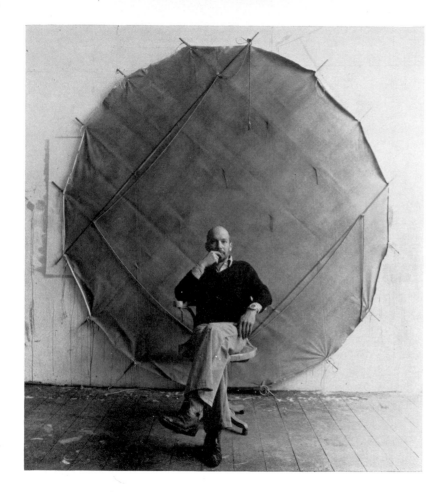

Richard Smith Seven Exhibitions 1961-75

Green Gallery 1961
Kasmin Gallery 1963
Kasmin Gallery 1967
Galleria dell'Ariete 1969
Kasmin Gallery 1969
Kasmin Gallery 1972
Tate Gallery 1975

Exclusively distributed in France and Italy by Idea Books
46-48 rue de Mont Reuil, 75011 Paris and Via Cappuccio 21, 20123 Milan
ISBN 0/900874/93/7
Published by order of the Trustees 1975
for the exhibition of 13 August - 28 September 1975
Copyright © 1975 The Tate Gallery
Designed by Sinc Ltd
Published by the Tate Gallery Publications Department
Millbank, London SW1P 4RG
Blocks by Star Illustration Ltd, London
Printed in Great Britain by The Hillingdon Press, Uxbridge, Middx.

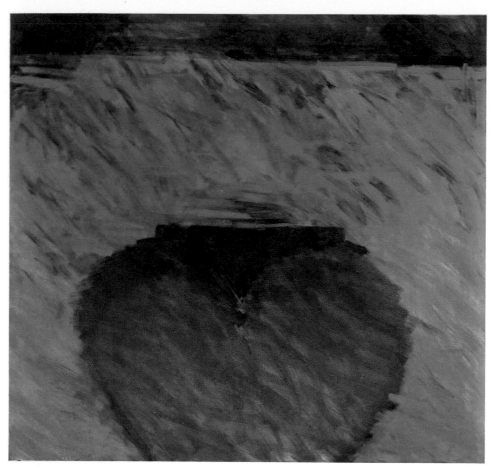

5 McCalls 1960

18 Piano 1963

Foreword

When an artist accepts the invitation to show his work in a major gallery or art museum he is not only laying it bare for the critical scrutiny of the public but, unless he has had many such opportunities he is making what is one of the definitive acts of his working life. What to include in the exhibition and in the catalogue becomes a matter of great concern for the artist and for the staff of the gallery to decide. Richard Smith, with his acute consciousness of "medium", has always applied an unusual degree of care and creative insight to the form and content of his exhibitions. For this retrospective at the Tate he has invented what I believe is a unique solution.

The show reassembles every painting in his six most important one-man shows The seventh exhibition is a group of recent paintings brought together especially for the Tate. The only additions to this scheme are two important paintings *Clairol Wall* and *Fool's Blue* which have never been shown in this country and a group of drawings.

We are most grateful to Barbara Rose who has written the introduction to the catalogue. She was the author of a very complete account of Smith's work in the 1968 catalogue of his exhibition at the Jewish Museum, New York, but this new essay seven years later provides a new assessment. The exhibition has been designed by the artist himself with the help of Jon Muncaster, and the catalogue by Gordon House. The nature of the exhibition has made it essential that we should obtain each single painting on the list and we are, therefore, especially grateful to the lenders who have made this possible.

I must express my thanks also to those who have helped us trace the pictures and have provided photographs and, information for the catalogue especially Richard Bellamy, Ruth Kelsey at Kasmin Gallery and the Galleria dell'Ariete in Milan.

Norman Reid
Director

Richard Smith

Richard Smith is an odd artist, at once in and out of touch with the currents of the mainstream. For the past fifteen years, his work has in some way contacted every variety of contemporary innovation; yet Smith has sworn no unconditional allegiance to any school or category of style. This duality – the ability to be *au courant* and aloof at the same time – is typical of Smith's personality as well as of his art. Because of the inherent tension involved in balancing simultaneously two (or more) essentially antithetical attitudes, his work continues to compel interest, to remain mysteriously and provocatively ambiguous.

There is a deceptive elegance to Smith's work: difficulties are so well hidden that it all looks simple, easy even. In a film called *Who Is Dick Smith?* made for CBS television in 1967, Smith names things or people he likes according to letters of the alphabet. 'A' reminds him of Fred Astaire whose seemingly effortless agility and flawless performance he admires. One can imagine why Fred Astaire could be an inspiration for Richard Smith. On film, Astaire has the perfect smile, the perfect clothes, the absolutely perfected routine of steps (refined of course through hours of arduous off-screen practice that turned a fabulous natural talent into an inimitable personal style.) Just as we never see Fred Astaire sweating or grimacing, we are never aware of Richard Smith's private doubts or agonies or interludes of pain or indecision. Yet to produce such problematic, at times difficult, works, the artist surely must endure such moments of *angst*. The public self is a debonair acrobat who performs with sureness and elegance; the private self is not exposed. As opposed to the *sturm-und-drang* of jagged brushstrokes, drips that mimic tears or blood, or the angry slashing of Abstract Expressionism, Smith's work is reticent regarding emotional content. We imagine him painting with 'a stiff upper lip', maintaining the *sang-froid* traditionally associated with the English temperament in crisis. Generally, Smith's sensibility is biased against Expressionism, despite his initial debt to the New York School. He appears to hold that in public behaviour – in this case art behaviour – a certain rigour, discipline and moderation is required. Thus his early paintings may be inspired by ideas about the glamour of show-biz, but they are never vulgar and 'showy'; his shaped canvases may be bulky and awkward, but they are always tidy and well-tailored; his recent series of stretcherless canvases may be informal, but they are never sloppy or tacky. It is of course always with caution that one refers to the 'Englishness' or 'Frenchness' of a particular artist; but in Smith's case it is difficult to refrain from concluding that despite his admiration for American painting, he could never find common cause with the unrestrained romanticism of the Expressionist side of the American sensibility because of his English reserve. Even the bittersweet nostalgia of Pop art in its blatant American version was too overt a display of sentiment, which may account for his refusal to paint popular subject matter, although he was fascinated by popular culture.

Like Fred Astaire's agile tap-dancing, Richard Smith's painting, once it leaves the studio, is an impeccable public

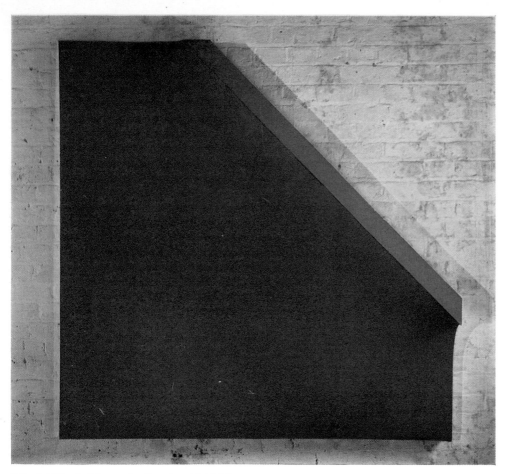

28 A Whole Year a half a day X 1966

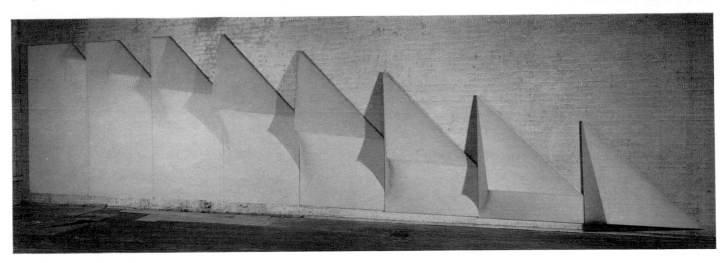

31 Clairol Wall 1967

performance, masking the artist's effort. This observation immediately leads us to another contradiction: despite its proper professional façade, there is nevertheless something vulnerable, personal, allusive and idiosyncratic about Smith's work. This quirky evocativeness sets his painting apart from abstract art that adheres exclusively to a vocabulary of standard geometric shapes joined in ideally uncontaminated relationships. Although it is nominally abstract, Richard Smith's art is constantly invaded by life, consistently adapting itself to the vicissitudes of the artist's personal experience. When the artist is a well-to-do young bachelor in New York, it is bright and glamorous. When he conceives of art as a kind of entertainment early in his career, a theatrical element is strong: qualities of physical presence, flashy colour and impressive public projection are stressed. When Smith and his wife Betsy move to Wiltshire, allusions to landscape make themselves felt, despite the artist's avowed attempt to avoid them. Domestic life in the country as the father of two young boys leads to thoughts of kites and *origami* folded paper cut-outs; a recent work, *Yellow Pages,* suspended above the viewer's head, reminds one of laundry hanging. None of these hidden references one may perceive is specifically literal. Nevertheless, the sense that shapes, forms, structures and images allude in some oblique way to the real world of common objects and human feelings reveal that, for Richard Smith, art and life are of equal value as stimulants for work.

Pop Goes the Easel

Growing up in the milieu that produced British Pop, Smith knew Lawrence Alloway, Richard Hamilton and Peter Blake. He faithfully attended the exhibitions at the avant-garde ICA gallery in London that launched pop art in England before it crystalized in America. At the height of his infatuation with the pop world, the Beatles as well as pop fashion designer Ossie Clark visited his Bath Street studio. Parts of Ken Russell's TV special 'Pop Goes the Easel' were photographed in his studio. Smith was a movie fan, followed all the new styles in design, wrote about jazz and rock-and-roll, made a film of his own and studied photography. Yet he could not bring himself to paint the actual images he found so brilliant and enticing in the slick American glossies that were precious collectors' items in London. Smith was attracted to, but not seduced by popular culture. As usual, he kept his distance. His first commitment was then and remains now to fine art. This commitment demanded that to be used for the purposes of art, popular culture had to be transformed by an artistic temperament, as nature had been subject to previous artistic transformation. After a certain point, Delacroix and the early modern painters could not simply transcribe nature without interpretation; similarly, Smith could not merely duplicate the man-made urban landscape of billboards, illuminated marquees, and streamlined buildings and machines that he found so exciting. Popular culture became for him man-made nature to be transformed by a temperament.

Reading Marshall McLuhan's *Mechanical Bride* — the first text analyzing the impact of media on perception,

which was studied in England before it was known in America – Smith became aware that techniques of mechanical reproduction had radically altered vision. Modern man now perceived nature second-hand; through the filter of media. This was a stunning realization that opened up for many artists beginning with Richard Hamilton in London and Robert Rauschenberg in New York, the possibility of a representational art based, not on the observation of nature, but on the imitation of images generated through reproduction. For Smith, it meant one could no longer be authentically inspired by nature because the landscape image with which one was most familiar was not the Wiltshire countryside surrounding Constable's *Salisbury Cathedral* (the area where Smith now lives), but the soft-focus blur of green in ads for mentholated cigarettes metaphorically equating cool tobacco with the freshness of a spring landscape.

Like Fernand Léger and Stuart Davis, Richard Smith is an artist of his time not out of conscious or programmed volition, but simply because he cannot help looking around. There is a naturalness, an ease, an organicity to Smith's modernism: he cannot help but view the world as phenomena to be critically analyzed. A personal vulnerability to external stimuli appears to have determined that his vision is inclusive as opposed to the exclusivity of *l'art-pour-l'art*. His images break their frames, his structures intrude into real space, his art demands the attention we give real objects in the world, as opposed to the distanced viewing we are apt to adopt when looking at art in museums, which began to be seen by the generation of artists who matured in the sixties like Smith as remote temples of art worship. Not the subject matter of Modern Times, however – the familiar hard-edge machine imagery, the industrial processes of fabrication – but its essential spirit of scepticism and self-inquiry is the essential content of Smith's work. As some are accidentally to the manor born, Richard Smith seems inevitably and unavoidably a modernist. There is nothing in his humble background as the only son of a printer in the provincial New Town of Letchworth that explains Smith's enduring commitment to the experimental, the analytic and self-critical spirit of modernism; yet this spirit is present in all of his works.

In contrast to the fanatical either/or stance of purist art, as well as in opposition to the permissive both/and fence-straddling position of the hybrid forms of collage and assemblage, Smith developed an independent attitude of neither/nor. Neither pop nor minimal, neither colour-field abstraction, nor literal three-dimensional object, Smith's work nevertheless addresses itself to the new issues raised by various developments of recent art as they manifest themselves. Although he always stops short at the outermost limit of painting – the point at which it might become sculpture, architecture, craft or theatrical spectacle – Smith constantly pushes at the previously defined parameters of his chosen medium, stretching the boundaries of his art at each encounter and subsequent redefinition. There is admirable courage in his willingness to face rather than to evade the problematic and the new; it is impressive, too, that the nature of his confrontation is never one of aggressive assault, but of reasoned discourse and engagement. Among the handful of artists of the Sixties capable of self-renewal, Smith has continued to evolve, develop and alter his art with a surprising degree

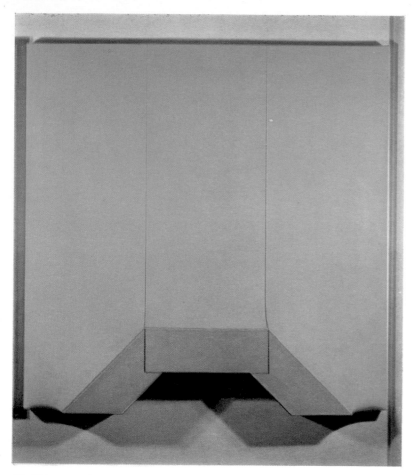

32 Western Stile 1968

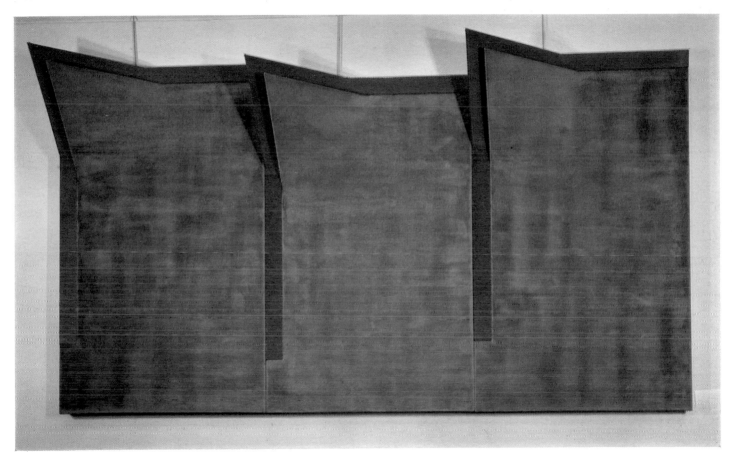

38 Passerby 1969

of flexibility and openness to changed circumstance, whether personal or artistic.

Despite its commitment to the self-conscious and self-referential demands of the modernist sensibility, Smith's art retains a tangibility that mitigates its strong conceptual thrust. He is not a hermetic or an esoteric artist. His imagery has a concreteness that always brings us back from the hyperion realms of the pure Idea to the down-to-earth world of commonplace experience. For example, there are constant references to such familiar structures as packages, envelopes, tents, kites, shutters, leaflets — the world of ordinary experience the artist shares with his audience.

Life in Art

Richard Smith's personality as much as his work represents a paradox: a modest man who has never displayed any pretensions to grandiosity or rhetoric, he has nevertheless made some of the most ambitious and peculiarly complex constructions in recent art. Elegant in dress and manner, he chooses to express himself simply, without bravado or flourishes. There is a certain asceticism in the reductiveness of his most recent works, which seem to reflect a general climate of world austerity. As he once celebrated abundance, so his latest works in the opening Tate exhibition space declare an aesthetic of survival: art continues to exist, even in a world of scarcity, reduced perhaps to a poverty of means — a narrow remnant shred of tautly stretched cloth, a few pieces of string. But the continuity of art signifies dignity in adversity. To continue, let alone to continue to innovate in the face of severely reduced economic possibilities and a waning conviction in many quarters regarding the survival of painting itself as a viable art form in an age of mass communication and mechanical reproduction, is a demonstration of rare tenacity and faith.

The sombre colours of the latest works are also reflective of a more sober mood. Now more than ever a moral quality dominates Smith's work. It is the counter-balance to the taste for a hedonistic display of colour, light and sensuous brushwork of the earliest paintings in the exhibition that date from the giddy encounter with New York. The choice to confront rather than to evade issues raised by developments both in art and life testifies to a rare steadfastness, especially as such engagement today is of necessity a border skirmish undertaken without flag-waving. In our post-heroic time, the best we may say about an artist perhaps is what Ortega y Gasset said of Goethe: that he took a stand within himself. To stand one's ground in isolation from a public or a market (Smith has been a critical rather than a popular or money-making success); to maintain one's conviction in art as worthy of a life's work; to negate the mechanistic attitudes of our civilization; to attempt to recoup what is vital in culture for humanist purposes; to redefine the parameters of painting, without transgressing boundaries that establish the essence of the pictorial; to make a statement that, because it comes out of lived experience, conveys an absolute authenticity — these are no mean achievements. In the absence of heroism, dignity may suffice.

The delights of bravura painting and story-telling art help us to escape from the hard realities of our world. Smith's early work — with its brilliant flourishes and

attractive, exciting images offered such aesthetic picnics. But the mature artist became, perhaps to his own surprise, an essentially moral character, who has less and less patience with illusion, greater and greater commitment to engaging with the Real, on all levels. His message, and I think we must assume that all artists of genuine merit have a message, is survival through the confrontation, not the avoidance of reality.

Up and About in New York and London

Always heading for the eye of the hurricane, Smith was drawn in the late fifties to New York, where challenges to the definition of painting were being most acutely posed, and a Post-Cubist style formulated. Earlier English artists like Gainsborough, Constable, Turner, and lately even Francis Bacon, had looked to the Continent for models of sensuous brushwork. But Smith turned his eyes in the other direction, admiring the fluid painterliness of American art, which he first encountered in 1956 at a show of works by Sam Francis in Paris. Francis' loose, open, airy brushwork and diluted, transparent paint persuaded Smith that de Stael's impasto was not the best way to create a sensuous airy effect. Smith was also impressed by Rothko's radiant, atmospheric large-scale paintings, which he saw in London also in 1956. Smith returned from his trip to Paris converted to the aesthetics of New York, but still painting Parisian: an aerial map of the grid of Manhattan executed in two-inch wide brushstrokes imitative of de Stael commemorates the turning point in his thinking. Three years later, he was sailing up the Hudson.

As the recipient of one of the coveted Harkness Fellowships which sent young British painters to America, Richard Smith arrived in New York City in 1959, a twenty-eight year old RAF veteran and graduate of the Royal College of Art. He looked up Ellsworth Kelly, whose high-key colour and hard-edged geometric shapes he admired. Kelly in turn introduced him to 'sign' painter Robert Indiana and other members of a group of artists including Jack Youngerman and Agnes Martin who had studios, like Kelly, on Coenties Slip, at the Southern tip of Manhattan near the seaport and financial district. Smith got a studio nearby on Whitehall Street and moved shortly afterwards to Howard Street in the same area. While he lived downtown, in the delapidated loft district, Smith dreamed uptown dreams. Claes Oldenburg's lower East Side *Store* celebrating Puerto Rican *bodega* culture was all the rage; but Smith was more drawn to the affluent pastel chic of Bonwit's windows than to the down-and-out garish splash of plastic *bodega* display.

Neither extroverted nor naturally gregarious, Smith nevertheless had an easy sociability and a large curiosity. He frequented the Cedar Bar, where he met other young painters; and he remembers brief meetings with Franz Kline and Mark Rothko. He went to happenings, movies, dancing parties and was generally considered an honorary member of the younger generation of the New York School, whose attitudes, interests and heroes resembled his own.

When Smith left England, he was imitating Sam Francis' floating washes of transparent broken colour. By the time he had painted in New York for a year, random brushstrokes were beginning to coalesce into patterns and

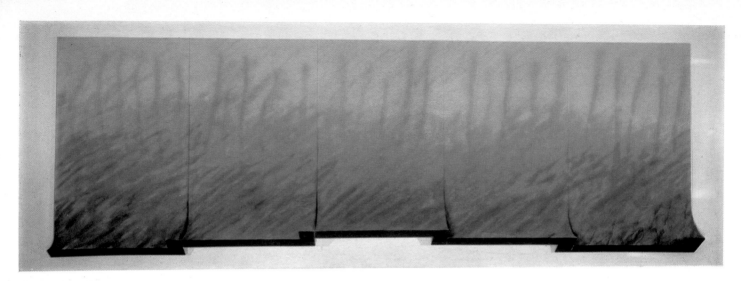

41 **Riverfall** 1969

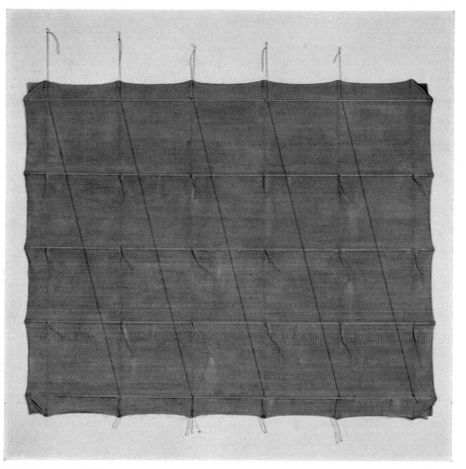

68 Livorno 1972

shapes with soft edges reminiscent of Rothko's hazy rectangles. In paintings like *Place,* forms were simple and bold, reflecting also the influence of Kline's ideograms. The colours were sharp and bright; they were not the muted colours of nature, but the pointedly artificial dyed oranges, magentas and acid greens of advertising and technicolour. Rothko had used high-key colour in early works, but he tended to maintain the flatness of his surface by confining his palette to either warm or all cool colours. Smith combined warm and cool, but minimized any illusion of depth by painting in discontinuous parallel strokes, which did not evoke the Cubist illusion of a series of planes receding behind the surface. Smith clearly defined surface as a continuous plane, on which a wash of transparent colour floated on top of the white canvas, which could be perceived between brushstrokes.

In the paintings done in New York in 1960-61, a circular motif, reminiscent of spotlights on a stage, was broken, bisected or quartered. Linear drawing was abandoned; soft edge blushes of pigment were conceived as structures for colour. Around this time, Smith met Kenneth Noland, whom he visited in Washington, D.C. where he saw Noland's first centred paintings. Although Smith never became a 'stain' painter, he was impressed by the luminosity of Noland's paintings, as well as by his use of simple motifs as colour structures that rejected the traditional use of drawing as an outline depicting shape. Through Metropolitan Museum curator Henry Geldzahler, at this time the social hummingbird who cross-pollinated the opposing camps of pop art and that of 'post-painterly' colour field abstraction championed by Clement Greenberg, Smith met art dealer Richard Bellamy, who was about to open the legendary Green Gallery where American art of the sixties was launched. Over Christmas of 1960, Smith went to Canada, where Bellamy, impressed by the freshness and assurance of the paintings he had seen, called to invite him to join the stable of Green Gallery artists, which eventually included Claes Oldenburg, George Segal, Lucas Samaras, Tom Wesselmann, Larry Poons, Robert Morris, Don Judd, Dan Flavin, Mark di Suvero, and Ronald Bladen.

Structure and Series

The current Tate Gallery exhibition, which begins with recent work and then turns back to re-create the first Green Gallery show, is arranged in terms of specific individual one-man shows that Smith has had since 1961. Thus, the retrospective itself becomes a serial event. Each room represents paintings initially seen together at a remembered time and place. The plan, which was Smith's conception, is typical of his way of thinking. The works created for each show belong to a single moment in history that cannot be repeated, but only recalled in retrospect. Because Smith always worked for a given show, a series reflects the mood of the artist generally. For this reason, there is a great variation from show to show. It is also typical that Smith would decide on a format first, and then adapt himself to the conditions arising from the consequences of that initial and to some extent *a priori* decision. Format determines structure; series in turn determines relationships. For Smith, the initial decision conditions the contents of the series, just as the shapes in Smith's paintings are filled in with applied colour.

In this context, one might mention that Smith always works on stretched canvas, although he has said he would like to work on the floor in the manner of 'stain' painters. As a result, his paintings, which are done on the wall, tend to orient themselves to the flatness of the wall. His images are either frontal, or in some way acknowledge frontality. Except for a few of the latest works, the picture plane, whether flat or projected, is parallel with the wall. Despite his revisionism regarding modifications of the nature of the stretcher, the surface, or the shape and structure of his painted field, Smith acknowledges the problems of easel painting as still worthy of consideration. His willingness to confront rather than avoid the essential issues is proof that he does not believe that the conventions of easel painting — 400 years of Western art — will simply disappear if they are ignored. The lucidity, rationality and consciousness with which Smith deals with what is left to us of the easel tradition once again single him out as an artist of extraordinary intelligence as well as exceptional character.

Except for the first room, containing works executed during the past few months for the Tate retrospective (thus constituting the final 'Tate show'), the exhibitions each re-create a given show Smith has had. They are arranged in chronological order, permitting a clear reading of Smith's evolution as a painter, as well as a rare opportunity to study the actual process of an artist's thought. To my knowledge, the exhibition plan is unique. It is yet another instance of Smith's willingness to be uncommonly candid. The quest for candor forces him to strip away illusion, revealing to a greater and greater extent the actual identity of a painting: how it is made, of what materials, what is on its reverse, how it hangs on the wall, etc. Smith draws our attention to the literal properties of painting that define it as a special class of object. In the sense that Wittgenstein speaks of 'pointing' as the first means of signification, Smith 'points' through emphatic isolation to the properties that define painting. There is another striking analogy with Wittgenstein in Smith's methodical investigation of the defining properties of painting. As Wittgenstein insisted that all essential philosophy could be reduced to ordinary language, so Smith has identified art with ordinary experience — not the experience of the brute or the banal, but with a vocabulary of imagery that links up, in ways more or less tangential, with the general experiences of everyday life.

Tate Gallery 1975

New works executed especially for this exhibition continue a line of thinking initiated in the multiple circles of canvas stretched on metal rods suspended over the viewer's head, which can be viewed from both sides, that decorate Mr Chow's Los Angeles restaurant. These in turn were an environmental extension of the paintings first stretched on rods, as opposed to conventional stretchers, shown at the Kasmin gallery in 1972. The commission to decorate a restaurant in 1973 provided an occasion for dealing with space as a total environment, a possibility of freeing painting from the context of the wall. Smith has always been explicitly conscious, not only of the illusionistic space in painting, but also of the relationship of a painting to the actual, three-dimensional space in which it is displayed. As much as any artist alive, Smith has analyzed and sought alternatives to the conventions of easel painting but never, as we have observed, by pretending that they do not exist *as conventions.* At first, he accepted the flatness of the wall as a given to be acknowledged and echoed. Until 1961, Smith painted strictly flat, frontal images. By 1963, however, he was experimenting with three-dimensional constructions that literally projected away from the wall. Later shaped paintings went even further in tipping planes at angles to the wall exposed behind them, as the white canvas is revealed in the early flat frontal paintings.

Smith's most extreme sortie into three-dimensional construction was the free-standing, tent-like construction *Gazebo,* executed in 1966. Despite its possibility of being entered like a garden pavilion, *Gazebo* was actually made up of a number of painted canvas rectangles – a hint that sculpture was not for Smith. Commissioned by a group of architects interested in environments, *Gazebo* was exhibited in New York at the American Institute of Architecture. Views around, through, and upward, as well as head-on or frontal vistas were offered to spectators who could actually enter the painted environment.

Gazebo was one of the last works Smith made in America. At the end of 1966, he returned to live in England, feeling that the 'party was over' in New York, and that America had become too entirely American, self-involved with its own problems. Certainly the community of young artists Smith belonged to was disintegrating as commercialism invaded the art world, and the problems of race relations and Vietnam began to tear apart American society.

However, Smith's debt to American art remained significant and enduring. For example, the idea of painting as environment derives essentially from the so-called Big Picture: the mural-size canvases of Pollock, Still, Newman and Rothko developed in New York around 1950. The Big Picture was the first real challenge to the conventions of easel painting. Larger than the viewer's field of vision, the Big Picture implied that the environmental quality of easel painting, in which peripheral vision, rather than the fixed focus of Renaissance perspective, played a leading role, could be recaptured in paintings that, like mural art, enveloped the viewer in their environmental space. The Big Picture was the first crucial challenge to the definition of easel painting as a distant object, apart and distinct from the viewer's subjective sense of himself as

existing in one kind of space that was actual, whereas the space of easel painting was an artificial illusion of a non-existent space.

Smith's concern with environments dates back to early in his career when he exhibited related paintings, all done in black, red and white in 1959, in an exhibition titled *Place,* a collaboration with Robyn Denny and Ralph Rumney held at the I.C.A. in London. *Gazebo* was a three-dimensional structure that the viewer could enter. Recent works like *Yellow Pages* and *Shuttle* explore other possibilities for using painting to create environments that fill actual space. *Yellow Pages,* inspired by the sheets of a telephone directory, like so much of Smith's work, suggests allusions to images encountered in every day life. A series of canvases stretched flat and taut, it is suspended above the spectator so that both sides are visible. Pancake-thin, these paintings define the flatness of painting as literal; front and back, they are surface and surface alone. As drawing was replaced by literal edge on a shaped surface, now the bulky projection of the wooden stretcher has been replaced by the light tensile strength of the aluminium rod.

Originally the portable easel painting was designed to be carried around by an individual (as opposed to remaining stationary in a church); Smith's recent works adapt themselves to an increasingly mobile culture of inter-continental nomads. They can be easily rolled, stored, shipped, restrung and rehung without tremendous fuss or expense. Their message is self-sufficiency. They can be made and installed by one man — without the aid of elaborate technology. At the opposite end of the spectrum from the grandly projecting shaped canvases of the 1963 Kasmin show that ultimately culminated in the fully three-dimensional *Gazebo,* the new works differ from sewn paintings by Americans Alan Shields and Richard Tuttle, to which they relate in many respects, by being explicitly *stretched.* Smith claims he does not understand why he cannot work on the floor; the answer may be because the irreducible essence of painting is that it is a coloured piece of *stretched* material.

Diary is a multipartite work of seven panels overlapping one another, hung at odd angles that increasingly approximate the normal horizontal-vertical axis of conventional painting. It is both a critique of paintings exhibited earlier this year at the O. K. Harris gallery in New York, as well as a recapitulation and reformulation of the serial theme of earlier works like *A Whole Year a half a day.* In New York at O. K. Harris, Smith hung three kite-like panels on top of one another; planes, no matter how thinned out so as to be overtly identical with surface, were piled on top of one another. This literal overlapping continues in *Diary.* But the canvases are spread out horizontally to revise the theme of sequential reading. The eye is carried along in a direction — in this case left to right reading is indicated by the gradual augmentation of the size of the dark brown band from a narrow strip in the first horizontal panel at the left to a heavy border in the final panel at the right. The movement swings upward, carrying the eye toward the ceiling.

The sunny gaiety of *Yellow Pages,* apparently echoing Smith's mood of euphoria on his return from New York in the spring of 1975, gives way in the current show to the austerity of *The Shuttle,* which like *Yellow Pages* defies gravity by being suspended above the viewer's head in mid-air. The theme of defiance is an almost imperceptible

but crucial *leitmotif* in Smith's work. At first there is the stubborn defiance of cliques and schools, then there is the consistent testing of the limits of painting, which always stops short of the moment when painting might become something else : sculpture, architecture, decor, or theatre. For Smith remains, despite his defiance of conventions, very much a painter. Light, colour and painterly surface are consistently his principle concerns : paint and canvas are never abandoned for newer materials, an indication of the conservative side of a defiant nature.

The First Green Gallery Show 1961

Richard Smith has a tendency to be surprising. It would have been natural for him to have become a pop artist. He enjoyed the 'forbidden pleasures' of popular culture as much as any well-educated young man inhibited by the genteel tradition. Although he regarded advertisements as sophisticated images reflecting the realities of contemporary society, they were not for him the heart of the matter. He thought pop imagery was 'like the *petit four* with the coffee.' It was the dessert, not the main course : 'You realized that you existed mainly on what you were eating. All that good protein from the museums — but what one really liked was the chocolate biscuits from the ads.'

Smith decided he would like the whole dinner. Somehow he would allude to the excitement of pop culture, without sacrificing the high art of abstraction to *retarda-taire* or illustrational representation. It is interesting that in speaking of art, Smith talks about food. Art for him is not something dry, abstract, and intellectual ; to begin with it was something pleasurable, attractive and sensual, just as today he might conceive of it, in the milieu of his family, as something light and playful.

Smith's first one-man show, as well as his first show in America, was held at Bellamy's Green Gallery in 1961. It established his reputation as a serious, intelligent young artist whose work, like that of his contemporaries, Jim Dine and Frank Stella, grew out of Abstract Expressionism in terms of its large scale, directness and impact, while at the same time rejecting the autobiographical and 'heroic' stance of action painting in favour of a cooler, more detached attitude and a greater openess to the sights,

sounds and sensations of the contemporary environment. In New York, Smith was very much at home ; Americans have always been very 'now' oriented. The Abstract Expressionists rejected the external social world out of hand. But younger New York artists found something attractive and exciting in media culture with its new fashions, new rhythms, new dances, new bold and blatant attention-getting images.

Although the Green Gallery showed pop art, Smith's paintings had little to do with the American Scene interests of artists like Segal and Wesselmann. Smith's point of departure was McLuhan's theory of mass communication. Because it was a theory, as opposed to simply a reflection of street life (a typically American reaction to the vitality of low-life or popular themes, from John Sloan and the Ashcan School through Pop art), that informed Smith, his method incorporating popular culture source material into his art was conceptual rather than illustrative.

The first Green Gallery exhibition was full of optimism expressed in high-key colour: hot reds, oranges and greens were banded together in a painting like Panatella like the stripes of a loud tie. The whirl of movement and blaze of light at the centre of Panatella recalls Turner's bleached skies and stormy seas as much as it does the cigar brand on which it is based. Bright colours reflected Smith's upbeat mood at finding himself suddenly in the land where the collector's items — the copies of the photo illustrated, ad-filled consumer slicks like McCall's, the title of one of the paintings in the show — were actually produced. Suddenly he was Poussin in Rome, looking at real antique sculpture instead of plaster casts. In New York now, American pop culture was no longer an exotic foreign Wonderland of marvellous shiny new gadgets — the latest in movies, styles, music and TV — it was home. There is an air of celebration and buoyancy about the 1961 Green Gallery show, reflecting a general good feeling among younger artists in New York, who had their own community, their own bars, parties, restaurants, hang-outs, etc. and were attracting the attention of adventurous collectors like Richard Brown Baker, who bought McCall's from the show.

Unlike a lot of pop art that tends to look in retrospect like the period style of the Sixties, Smith's paintings, although inspired by contemporary images like Times Square billboards, colour photographs and Cinemascope movies, remain fresh and vital because their sources have been subsumed by a transcendant preoccupation with structure, colour and painterly surface which establishes the priority of form over subject matter. Blurred edges of indefinite large shapes might as well be inspired by Rothko as by a glossy colour ad, printed off register in its millionth copy ; what matters is that the feeling, as opposed to the time-bound paraphernalia, specific signs, objects and images, of contemporary life were translated into pictorial equivalents.

As Mondrian tried to express the syncopation of jazz in his New York painting Broadway Boogie-Woogie, Smith captured some of the excitement and optimism of naive pre-assasination America with his whirling discs and rotating pentagons which give the impression of a rush of movement, an explosion of vitality tempered by Smith's own innate sense of structure and discipline. These first paintings Smith showed in New York proclaimed no startlingly new vision. The shapes were simple and frontal ;

the frame was the traditional rectangle. Smith only resorts to new media and new techniques as the solution to a formal problem posed by the preceding series of works. The problem resolved in the Green Gallery paintings was that of structuring colour and brushwork into legible shapes, which demanded no new media or techniques.

One can trace the development from *McCall's* and *Penny,* with their relatively undisciplined brushiness, to the ordered legible shapes of *Panatella* and *After Six,* in which long thin brushstrokes are lined up in parallel rows. Each time the direction of the stroke changes, another shape is created. Since the strokes as well as the paint texture are uniform, and value contrasts are minimal, the plane of the surface remains intact, unbroken by any consistent illusion of receding depth. Atmosphere and illusion are made compatible with the acknowledgment that the canvas is literally a two-dimensional surface by brushing on very diluted, transparent paint in a manner that suggests a shimmering brilliance of a *film* of colour.

Generations of artists from the Synchromists and Orphic Cubists on dreamed of a colour-light art. By studying the quality of light created by projected images, Smith appears to have come closer than most to achieving such paintings of pure colour-light. His film of colour resembled a coated emulsion that did not sink in behind the picture plane. In a different manner, Smith achieved the same goal as Noland, Louis, Frankenthaler and the 'stain' painters; instead of identifying image with ground by staining colour into raw canvas, he conceived of the canvas as a kind of screen on to which colour was projected through a medium of light. That disc, round or odeon forms predominate in this series is probably an outcome of Smith's

interest in projections. The aperture of the projector or spotlight is round like clocks, pennies, lipsticks, pills and cigar bands — some of the objects that were points of departure for the circular images that predominate in his paintings of the early sixties.

Unlike Noland's bulls-eyes, which are contemporary with these works, Smith's images are deliberately *not* quite centred. Composition is determined not as a result of precedents in painting, but through an analysis of the transformation of images in reproductions. The relationship of image to rectangular frame is determined by conceiving of the rectangle as a viewing screen or frame as in a camera viewer, which cuts off in a photograph whatever is not included in that selective field of focus. Smith has described himself as a bad photographer who always got things out of focus. The issue of focus, as well as that of image-frame relationships are essentially issues raised by photography and first explored in any depth in painting by Degas, himself also an amateur photographer.

Smith's images are off-centre and partially extend beyond the frame, as if they have been cropped by the frame. In *McCall's,* the heart shape, so familiar we can finish it mentally, breaks the frame, looking too heavy, too gravity-bound to be contained by the lower edge of the stretcher. *McCall's* is an elaborate pun on the *cliché* phrase 'the heart sinks'. A 'broken heart', which is what *McCall's* actually depicts, is the theme of the true confession-style love stories contained in the popular ladies magazine from which the painting takes its title. (A drawing of the painting was a present to a girlfriend, whose puzzlement at his reticence Smith took to mean rejection.) *Billboard,* according to Lawrence Alloway, is an enlarged Air Mail

envelope, decorated as homage to a far-away lover. A horror of sentimentality keeps these references carefully concealed from any general public; the irony of the buried reference is typical of Smith's wry wit, as well as of his incapacity to keep his life out of his art.

Degas was mainly interested in new compositional possibilities suggested by cropping an image; Smith refers to the later technology of cinema, which permits close-ups, the camera zooming in and out from an object on which it focuses, as well as odd, distorted views that caused the reformulation of perspective that Degas was the first to realize suggested a radical alteration of pictorial space and composition. In the second Green Gallery show held in 1963, Smith began investigating some of these themes more systematically. A show held in his London Bath Street studio the previous year had brought him a certain modest acclaim and enough money from sales to return to New York. Studying the stylized perspective of tissue box and cigarette ads, which had the natural advantage of being rectangular forms morphologically related to paintings, he began altering space through the use of partial anamorphic perspective. In paintings like *Tissue, Soft Pack,* etc., the image is presented as if in a film close-up: rapidly foreshortened and looming precipitously toward the viewer. In 1962 Smith made a film called *Trailer,* which featured close-ups of different cigarette packages seen from various angles. The duplication of images only slightly modified from frame to frame obviously inspired the repititions of adjacent images in paintings like *Trailer I* and *Trailer II.* The relationship of images in film frames to one another crops up again much later, in the progressive alteration of an image 'zoomed' in on in sequential works like *Clairol Wall* and *Diary,* and serial works like *A Whole Year a half a day.*

Kasmin Gallery 1963

The step into literal three dimensions was logical once Smith began using perspective in his paintings. The rectangle is still the essential module in paintings like *Piano* and *Gift Wrap* that jut out into the viewers' space with an aggressivity that is rare in Smith's work. Originally thinking of the shadows cast by objects (he speaks of being impressed by a painting by Francis Bacon including a cast shadow of someone outside of the painting), Smith repeated the rectangle that, like Duchamp's *Nude Descending the Staircase,* is seen in subsequent positions, as if a zoom lens had simultaneously registered in double and triple and finally quadruple exposure, the successive images receding or advancing in space. In *Re-Place,* the 'shadow' is cut out, suggesting that the whole rectangle might be cut and folded to project forward. Smith was working at the time with cardboard models; and it is not difficult to imagine the progression from model to finished work. The horizontality of *Gift Wrap,* as well as its biting acid colour, still applied in loose sensuous brushstrokes, is reminiscent of the space and colour of Cinerama wide-screen movies.

This is the last series of works Smith made that relate in any way to specific popular imagery. The only later work to refer to ads was *Clairol Wall* of 1966. It was inspired by a specific advertisement of the same girl seen many times in juxtaposed shots, her blonde hair tinted each time a different yellow. The 1963 Kasmin show was still infected with the euphoria of 'swinging London'. So attractive and compelling are the sharp colours and bold shapes, we almost lose sight of the more

basic theme of this dramatic series: the relationship between the literal and the depicted, the illusionistic and the actual. *Piano* is a stunning piece; the rhythm of its repeated dots and stepped orthogonal lines draws our attention from the way depicted rectangles overlap to spill over and contradict the shape of actual rectangular canvases stacked on top of one another, in a manner reminiscent of Jasper Johns *Triple Flags.* In Johns *Triple Flags,* the same image is repeated and reduced each time with a relentlessly predictable logic. *Piano* is freer, more exuberant, more a rhythmic reflection of the lively beat of pop music than a static icon. Resting on the floor, intruding into the spectator's own space, it is an impudent bid for attention — the ultimate 'close-up' that eclipses any remaining distance between viewer and object.

The next two years of Smith's life were spent searching for new modes of synthesizing colour and structure. A change to acrylic paint in 1965 immediately caused edges to harden, brushwork to be effaced in favour of a uniform, unmodulated surface. It was a time of considerable experimentation in Smith's life, which included the radically protruding 'Sphinx' series of standing constructions, which pushed forward the picture plane from the wall into the viewer's space while remaining decisively frontal in their orientation. This problematic series culminated in multipartite shaped canvases based on an envelope motif that reconsidered, in a new context, the concern with focus, surface, and the indentity of shape with colour. Works shown at the Richard Feigen gallery in New York in 1967 including *Sea Wall* and *Envelopes*

emphasised the canvas as a tangible physical object that could be bent and folded to the artist's will. *Ring-a-ling-ling,* one of the most successful in this series, combines two colours of red of minimal contrast; the darker crimson serving as a colour field curved to meet a flat plane of orange-red. Three canvases, each with a successively larger arc cut out of the upper right hand corner, are bolted together. By now, illusion has been banished. At this point, space is literal and edge, defined by the beginning of a new surface as opposed to a drawn line, is equally literal. Shadows created by curving canvas are actual; shape, colour and structure are tied together inextricably. The degree of projection of these 1966 polyptychs incites the viewer to look at the work from different angles, to walk around and inspect the sides (in the case of *Ring-a-ling ling* made of shiny aluminium) as well as the front of a work. The redefinition of painting as three-dimensional physical object at this time was made in an atmosphere of general discontent in New York regarding the limits of painting. Don Judd and Dan Flavin, claiming painting was dead, were translating formerly pictorial qualities such as light, reflection, colour, space and surface into their literal equivalents. Smith, as always, was very much aware of the dialogue.

Kasmin Gallery 1967:
A Whole Year a Half a Day

The most extensive work Smith has designed, the twelve panels of *A Whole Year a half a day*, was conceived, specifically for Kasmin's gallery. In format, it belongs with the series of works that began earlier in 1966 with *Miami Moon,* three paintings ending in *New Moon,* in which the coloured border of a deeper orange yellow becomes progressively slimmer in relation to a lemon yellow border. The three *Corner Pieces (A, B,* and *C)* also belong to this group of works done in 1966, which includes *King Edward I, II, III. A Whole Year a half a day* like the recent *Diary,* refers to a calendar — a rectangular page from which leaves are torn off. It looks back to Smith's initial concern with close-ups of images. Now, however, each image in the sequence, or each frame in the film if one wishes, is focussed on individually. The twelve canvases which have been broken up since their initial showing and sold to separate parties, quite literally constitute a single, sequential serial work, representing more than images related in format, shape or colour, they are related as a sequence of images, the whole of which can only be experienced in memory. Each individual painting is but a part of the whole sequence. To perceive the totality of what was planned as an environment surrounding the viewer on the four walls of the gallery, one must 'read' the 'history' of the progressively altered image, perceive how the rectangle is gradually being eaten away, as life is used up in living. *A Whole Year a half a day* deals with the theme of memory. Each canvas has a past and a future; even the first and the last connect in an eternal return, if we think of their relationship as that

of the crescent moon to the full moon which inevitably succeeds each waning crescent.

Memory is one aspect of morality. It is anathema to the professional vanguardist who would like to deny the meaning of history. In Smith's work, however, renewal does not mean the denial of history or memory, but the reconstitution of experience in terms of a changed context. The past is re-evaluated as opposed to devalued, which is perhaps why Smith's work looks new and fresh but not novel.

Galleria dell'Ariete 1969

The multipartite paintings of 1966 ultimately resulted in works like *Clairol Wall* in 1967, in which the entire sequence of successive formal permutations was indissolubly bolted together. The dense opaque surface created by acrylic paint together with the deliberate effacement of brushwork and Smith's limitations of his palette to two close-valued nuances of the same hue or finally monochrome colour placed greater emphasis on structure. The concentration now was on the creation of a surface that could be shaped and twisted to defy once sacrosanct frontality. Paintings shown in Milan in 1968 continue these primary concerns with altering structure and surface. A greater unity is achieved by conceiving of the painting as a single continuous surface broken only by folds and cuts, as opposed to a series of permutations of joined panels. Colour contrast replaces the extreme reductiveness of monochrome.

Research regarding a split form initiated in the 1965 construction *Spread,* in which the two halves of the painting were parted to arch out into opposite directions, are resolved by reducing the amount of projection to a minimum. Simple, primitive arch and post and lintel constructions are evoked in works like *True North, East Gate, Southern Limit* and *Western Stile.* There is a classicism in the restraint – the degree of shaping is subtle and tightly controlled, the colours are harmoniously paired for pleasing contrast. Monumentality is strengthened by the archaic simplicity of rudimentary forms. Frontality is reaffirmed ; the coloured bands that project towards us are once again parallel to the wall behind them. Colour is rich

and vibrant; but only in a piece like *Plum Meridian,* which swells out into a voluptuous petal-like arrangement, do we feel the echo of the sensuousness of Smith's earlier works. The possibility of seeing up underneath the shaped stretcher establishes the actual dimension of the painting. Illusion now is no longer depicted, or even handled ambiguously as in the 1963 Kasmin Gallery paintings like *Piano.* There is a new resolve and calmness to these works, which suggest the sturdiness of Romanesque masonry, the resolved balance of moderation.

The paintings shown at the Galleria dell 'Ariete represent the only true serial paintings Smith has produced. For in contrast with the American conception of serial works developed by Stella, Noland, Kelly, et al. as a number of paintings with similar formats and colours, Smith has been concerned, with the exception of this group of works done for the Milan show based on architectural motifs, with *sequence* as opposed to series. *A Whole Year a half a day, Clairol Wall* and other works done from 1966 to the present are involved with an image that changes from panel to panel in a manner that requires a sequential reading in time. That a given single panel has a 'past' as well as a 'future' distinguishes Smith's work from that of American painters with the exception of Jasper Johns, who has also explored the possibilities of sequentially related images.

Smith's involvement with continuity, sequence, history and memory sets him apart from his American contemporaries who became committed in the Sixties to an art that denied any ties to history, instead emphasizing images that could be immediately communicated at one glance, in a single instant: the present moment to the exclusion of all else. It is perhaps not coincidental that Smith's involvement with sequence — successive moments that require time to read — should coincide with his decision to return to Europe.

Kasmin Gallery 1969

Riverfall and *Amazone* continue the direction announced in *Plum Meridian.* A flood of colour is dammed by a horizontal band of a contrasting hue. Both are large, vertically split canvases butted together, and billowing into a rhythmic ripple pattern at the bottom, as if gravity were pulling colour down. Colour volume rather than shape is important now. The colours themselves are dark and rich; they are applied alternating spray and brush in many layers until the canvas is thoroughly coated. In *Riverfall,* the final coat of transparent shimmering green colour is reminiscent of the 'hedges of colour' of Smith's early paintings. *Malaya* and *Passerby,* on the other hand, recall Smith's cut and folded lithographs and etchings, which initially suggested the possibility of two 'sheets' or layers bent and folded back. Now canvas surface begins to be treated like a page, and that curious symbiosis between painting and print-making we observe in Jasper Johns' recent works becomes an important factor for Smith as well. Graphite, pastel and charcoal additions enrich the material quality of surface as something physical that the artist can alter, as he formerly altered structure. Transparent layers of paint imitate the processes of printing, which calls for the additions of plates inked with different colours. An increasing concern with rich surface texture evokes an ironically tactile response to an optical experience.

Kasmin Gallery 1972

The concern with surface appears to have persuaded Smith, as it has also persuaded Jules Olitski, Walter Darby Bannard and Larry Poons, to become increasingly concerned with texture. Like them, Smith seems to have concluded that painting differentiates itself from other objects in the world not only because it is flat, but also because it is surface and surface alone. That surface, i.e. the canvas support, could be detached from a conventional stretcher was a realisation that came to Smith once again as the solution to a specific practical problem. The radically shaped constructions were bulky, difficult to build, transport and store. He was looking for something economical, something he could handle alone, the possibility of a cottage industry. Remembering a tent he had designed while participating in the Aspen Colorado Design Conference in 1966, he began to think of ways of stretching canvas on rods as collapsable tents are erected on poles.

The so-called 'kite' paintings begin in 1972 and were shown at Kasmin's gallery the same year. They reverse the conception of the importance of the stretcher.

The movement of thesis-antithesis-synthesis is characteristic of Smith's thought process. This process is deliberately exposed in the choice of key shows and works that permit the viewer to follow the evolution of the artist's conception as it evolves. Thus, Smith's investigation of the possibilities of manipulating and altering the stretcher may be seen as coming to an end in the 1969 *Fool's Blue,* which is actually nothing but the stretcher itself cut into repeated scallops.

As opposed to the brilliant high-key colour of *Clairol Wall, Fool's Blue* is dark and sooty. Colour in Smith's work is evocative; he thinks of 'sweet' and 'sour', 'sharp' and 'dull' colour, for example. Typically, he will rapidly shift gears, changing from a bright to a dull palette. Recent works like *Grey Slice* are experiments in using the grey scale that parallel Ellsworth Kelly's latest works which also abandon chromatic colour for the shades normally associated with *chiaroscuro*.

The so-called 'kite' paintings are the antithesis of *Fool's Blue*. From a painting that is *all* stretcher Smith has arrived at the notion of paintings that lack any stretcher.

The first 'kite' paintings exhibited at Kasmin's gallery in 1972 were roughly rectangular. At first, wood struts supported the stretched canvas, but these were quickly exchanged for sturdier, more flexible aluminum rods. Threads and tapes were stitched and woven through the canvas, changing the character of the support as well as that of the stretcher. The tapes were analogues of brush-strokes; the threads literal equivalents of lines. As the 'kites' became more elaborate, Smith began painting shapes and bands on rectangles. Gravity determined the angle from which the painting would hang, however, so that suspended from a string or rope, the rectangular canvas would find its own balance, and hang at an oblique angle to the normal vertical. The next series of 'kites' were exhibited at The Garage the following year at the same time Smith was designing the hanging discs for Mr Chow's L. A. restaurant. These in turn were followed by the overlapping 'kites' shown at O. K. Harris gallery in New York in November 1974, a series that was refined in paintings shown in the Caracas, Venezuela exhibition held in July, 1975.

Like the circularity of the full-moon, waning crescent juxtaposition, the last show and the first meet at this point. The beginning becomes the end; renewal is born of resolution. In the latest works made especially for the Tate exhibition, the extreme tautness of the stretched canvas suggests a new inner tension; sombre colours indicate a more pensive, less celebrating mood. The conception of the stretcherless paintings that are surface alone has finally coalesced: separable elements are once more thoroughly synthesised in the new format. Once again, shape, structure, form and colour are one. Rods are not only functional; they replace drawn lines as literal inflections of unbroken areas of monochrome colour. The dangling strings are literally pulled down by gravity. Inevitably, they echo the verticality of man's own gravity-determined vertical stance. The form of the sequential panels of *Grey Slice* evoke stretched hides. Canvas suggests a membrane, like skin. These consistent allusions to the human condition prove that abstract art is not necessarily divorced from man's experience. To keep art and life in balance — while daring to explore the extremes of risk — is no mean feat, even for a fancy juggler with long hours of solitary practice. Picasso was not wrong to picture the modern artist as a lonely harlequin, stranded alone in a family.

Barbara Rose
New York, 1975

Acknowledgements

I wish to thank Kynaston McShine, Richard Bellamy, David Whitney and Henry Geldzahler for their help. I am especially grateful to Richard Smith, without whose co-operation I could not have written this text. All quotes are from unpublished interviews with the artist by the author.

Barbara Rose

Green Gallery 1961

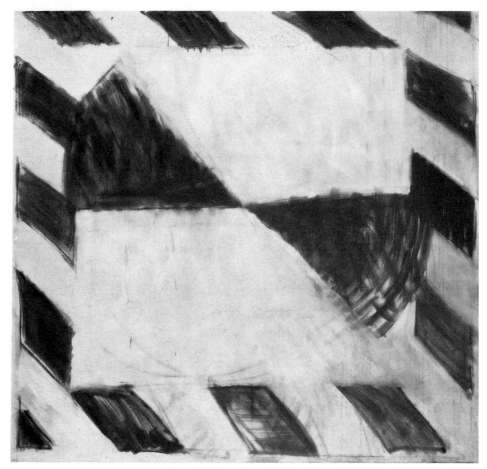

1 After Six 1960

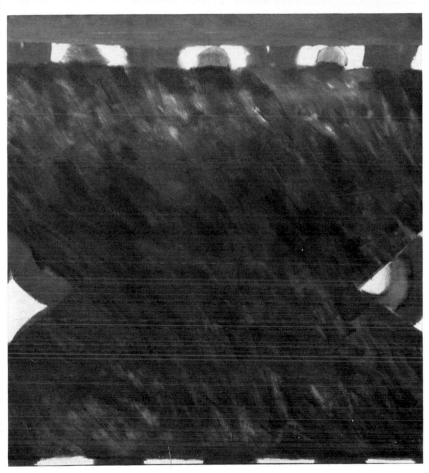

2 **Penny** 1960

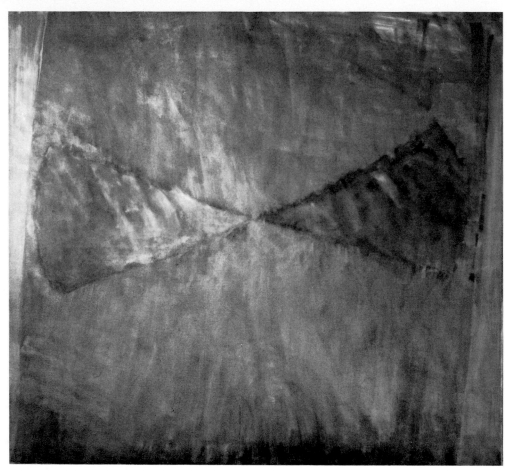

3 Formal Giant 1960

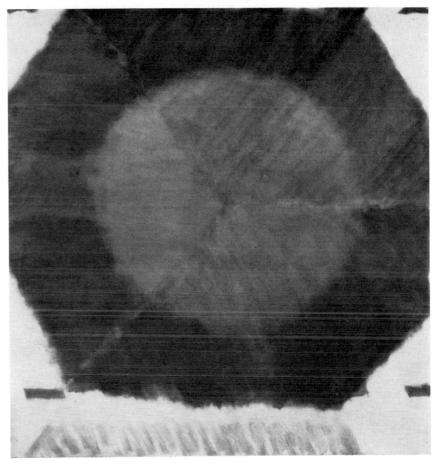

4 Somoroff 1960

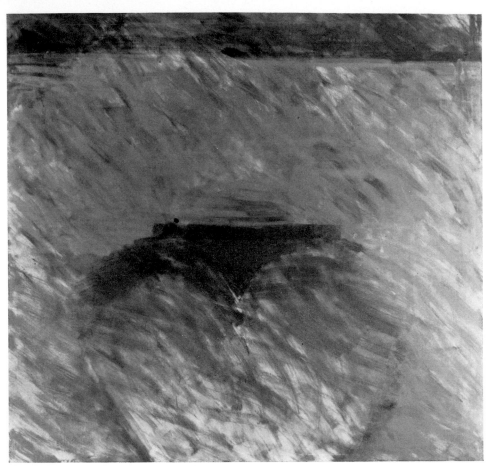

5 McCalls 1960

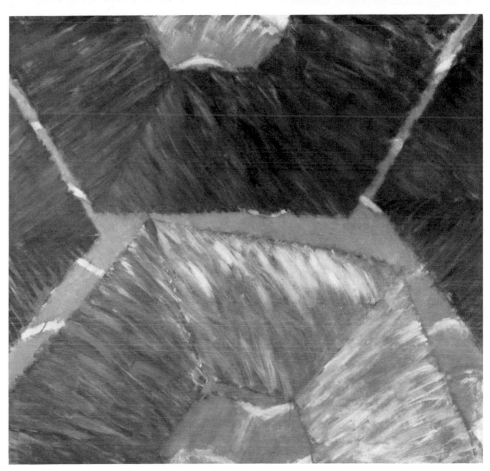

6 Chase Manhattan 1961

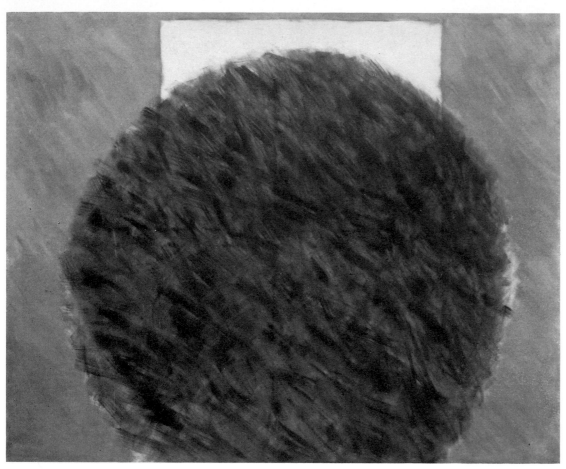

7 Revlon 1961

8 Billboard 1961

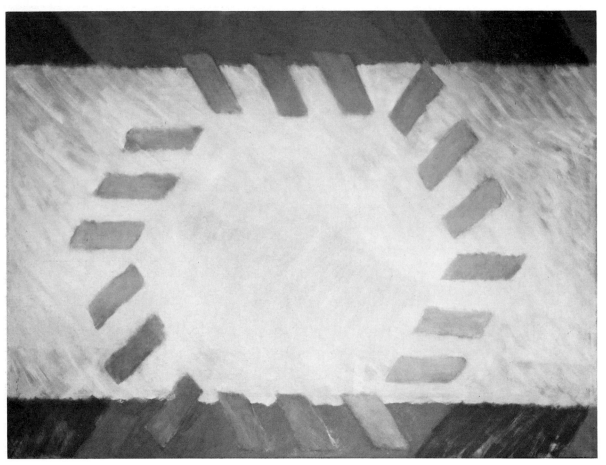

9 Panatella 1961

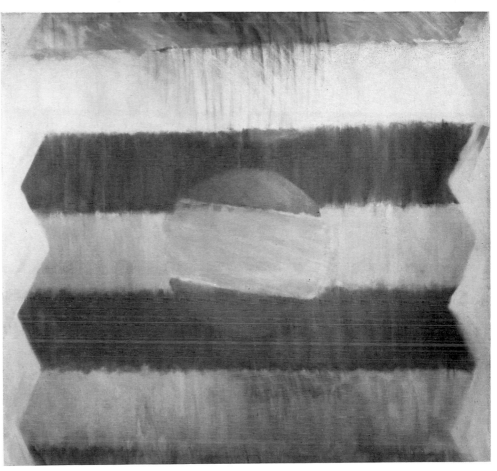

10 Capsule 1961

Bath Street Studio 1962

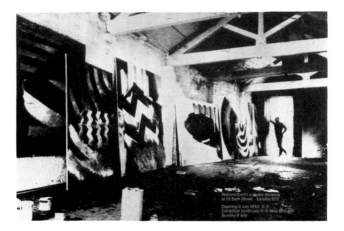

Institute of Contemporary Arts 1962

Richard Smith Recent Paintings
ICA
Institute of Contemporary Arts 18 October - 24 November 1962
17 - 18 Dover Street London W1 Daily 10 - 6
 Saturdays 10 - 1
Admission 1s Members free Closed Sundays

Green Gallery 1963

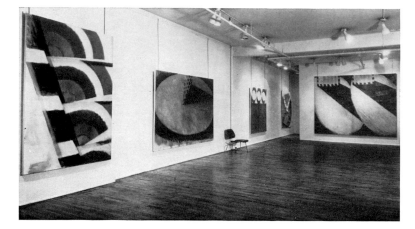

Kasmin Gallery 1963

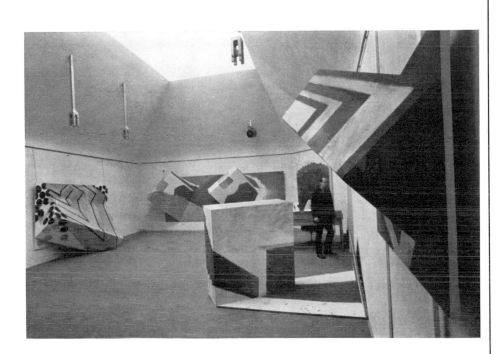

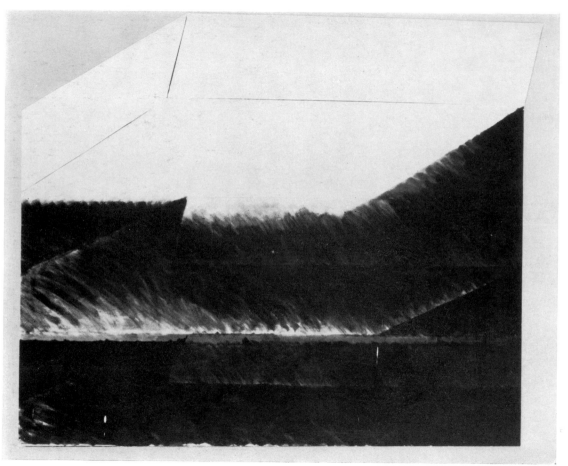

11 Pagoda 1963

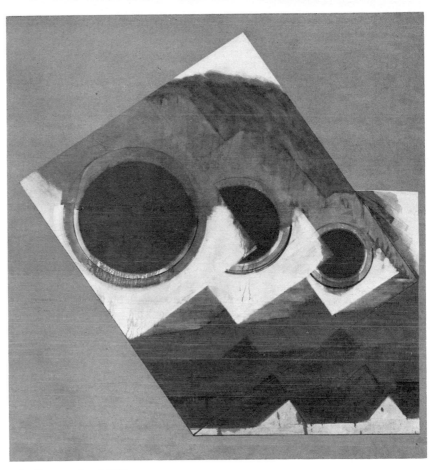

12 Staggerlee 1963

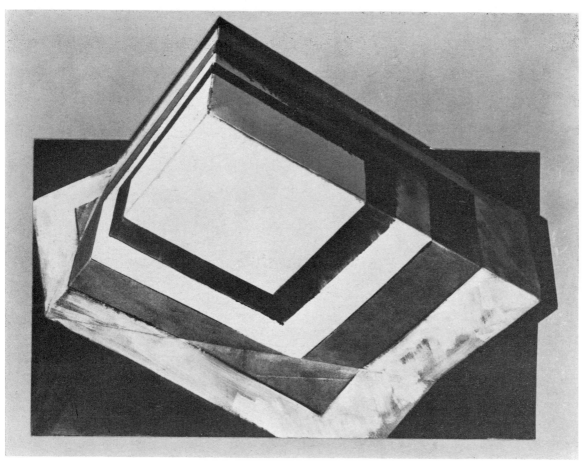

13 Surfacing 1963

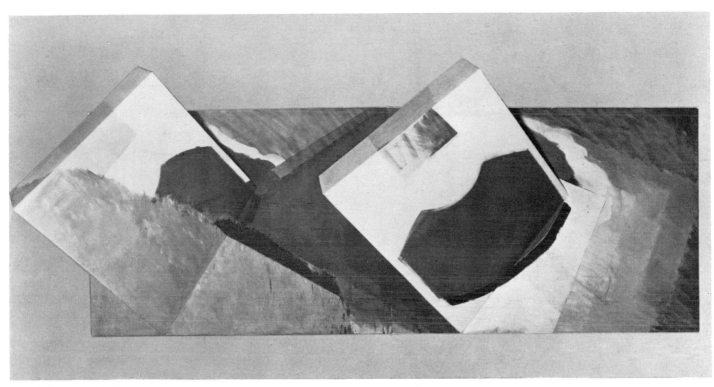

14 Gift Wrap 1963

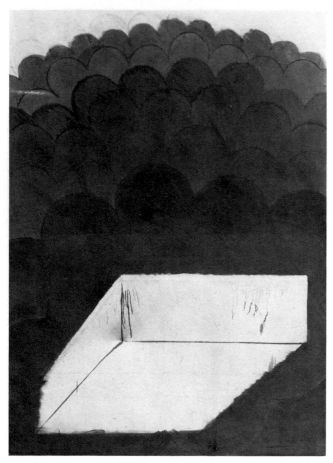

15 Lonely Surfer 1963

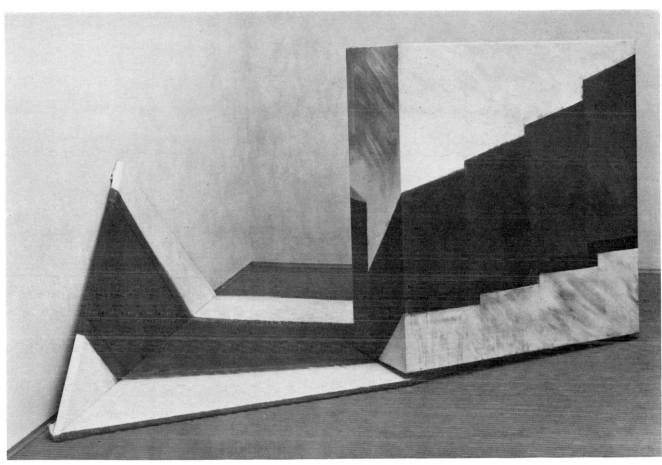

16 Re-Place 1963

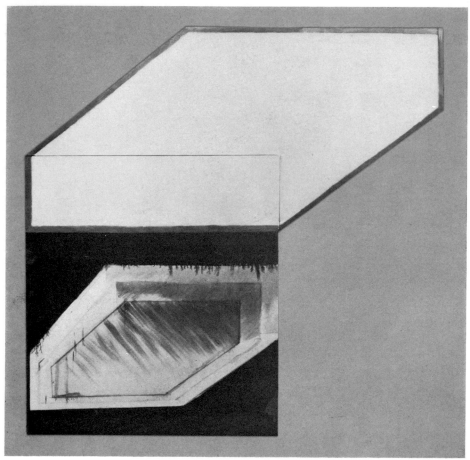

17 Fleetwood 1963

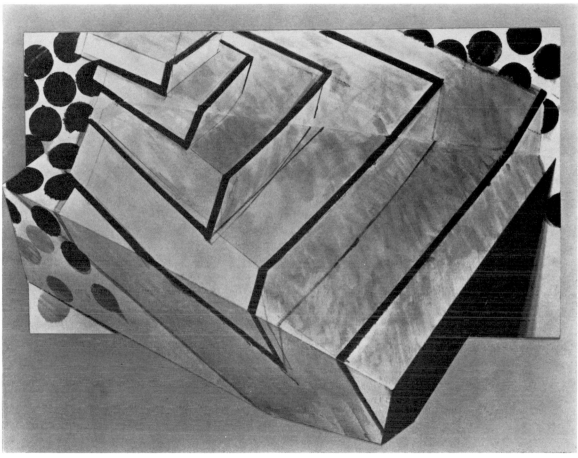

18 Piano 1963

Green Gallery 1965

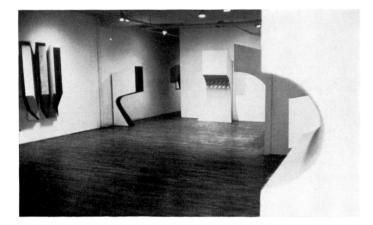

**The Whitechapel Gallery
1966**

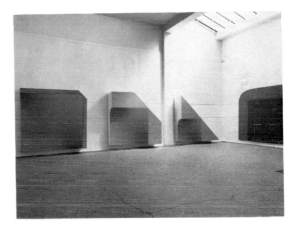

**Richard Feigen Gallery
1966**

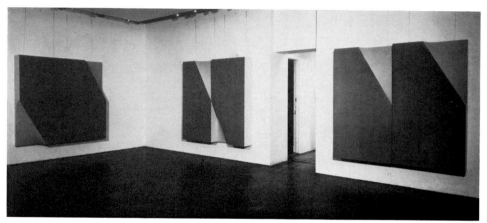

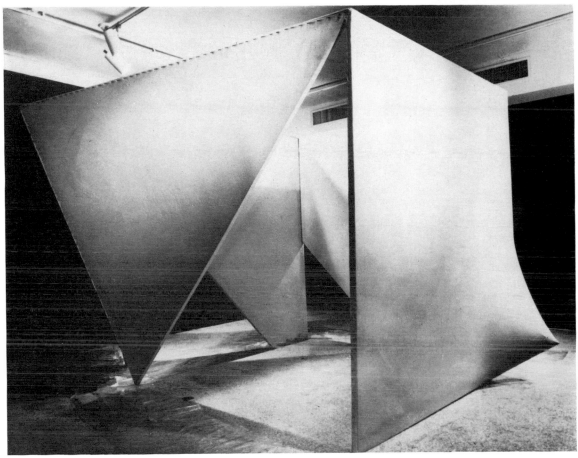

Gazebo 1966
Acrylic on canvas 95½×95½×95½ in/ 243×243×243 cm
Architectural League of New York

Kasmin Gallery 1967

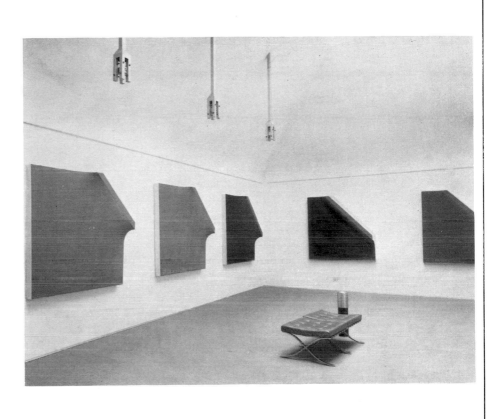

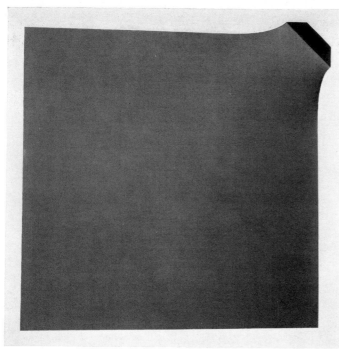

19 A Whole Year a half a day I 1966

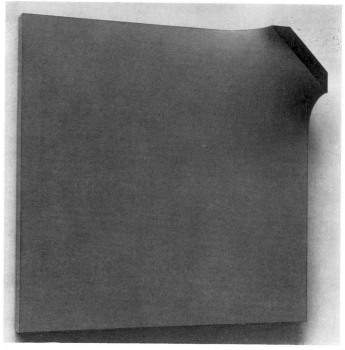

20 A Whole Year a half a day II 1966

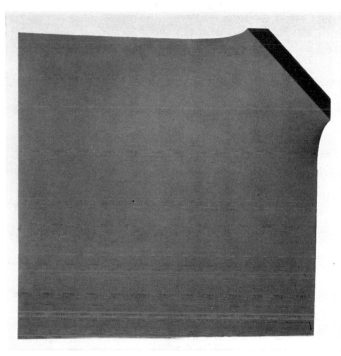

21 A Whole Year a half a day III 1966

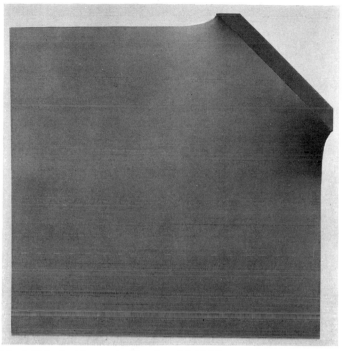

22 A Whole Year a half a day IV 1966

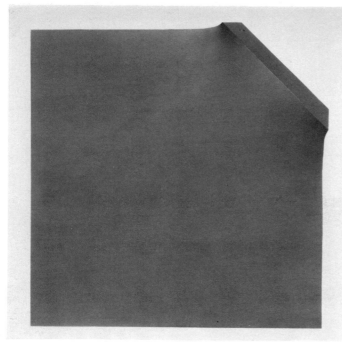

23 A Whole Year a half a day V 1966

24 A Whole Year a half a day VI 1966

25 A Whole Year a half a day VII 1966

26 A Whole Year a half a day VIII 1966

27 A Whole Year a half a day IX 1966

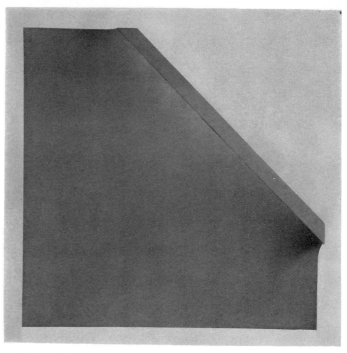

28 A Whole Year a half a day X 1966

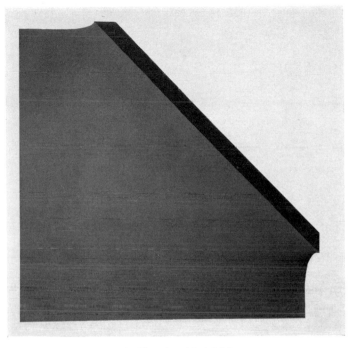

29 A Whole Year a half a day XI 1966

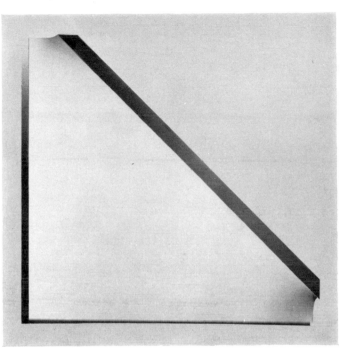

30 A Whole Year a half a day XII 1966

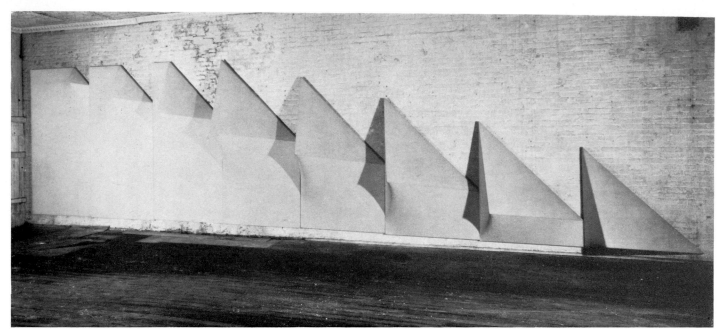

31 Clairol Wall 1967

São Paulo Bienal 1967

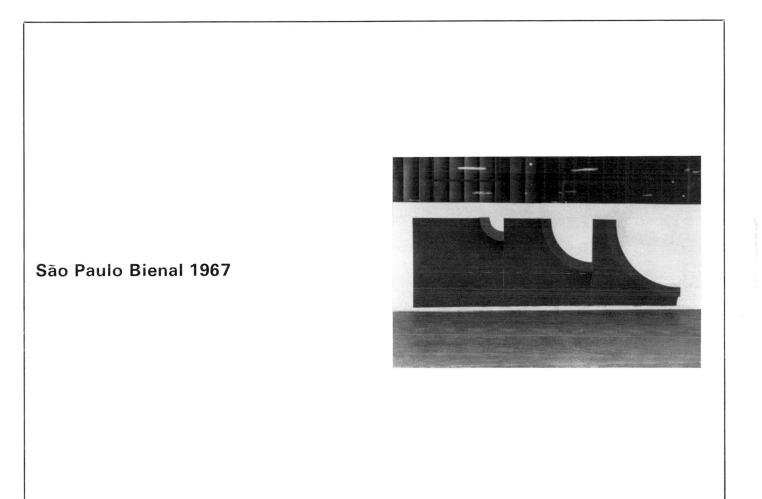

Galleria dell'Ariete 1969

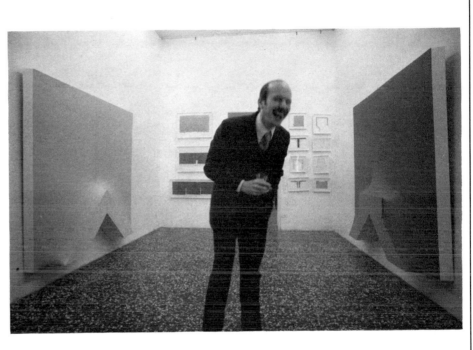

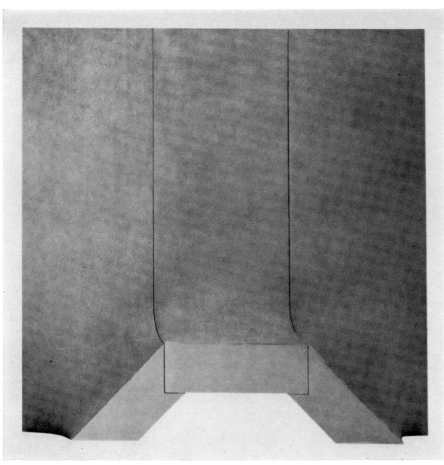

32 Western Stile 1968

33 True North 1968

34 East Gate 1968

35 Southern Limit 1968

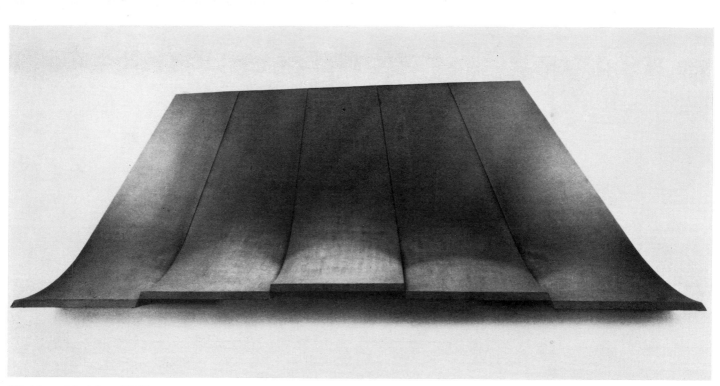

36 Plum Meridian 1968

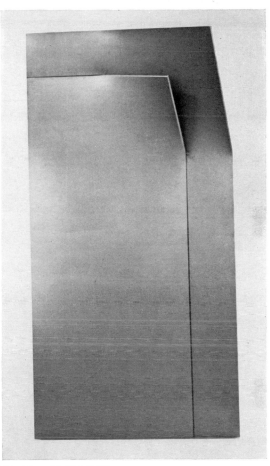

37 First Half 1968

Kasmin Gallery 1969

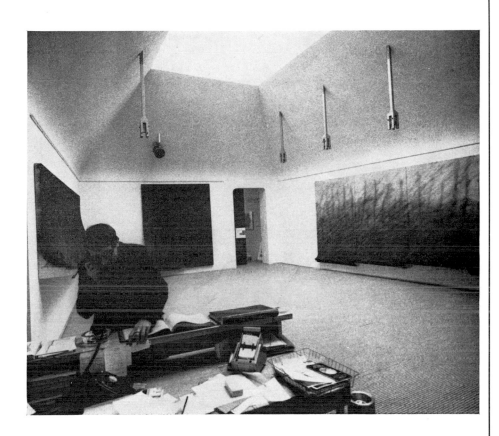

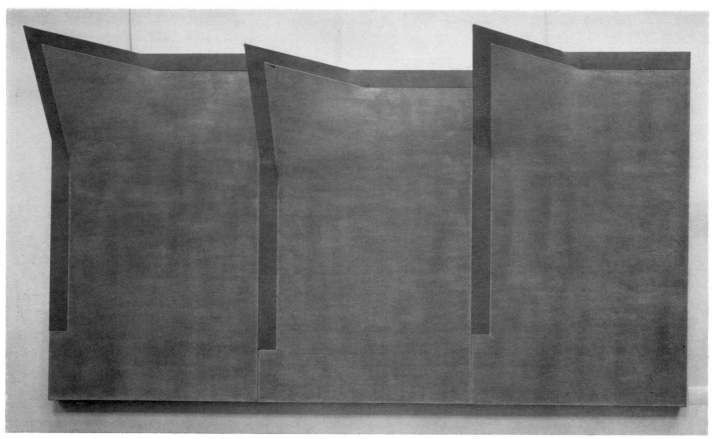

38 Passerby 1969

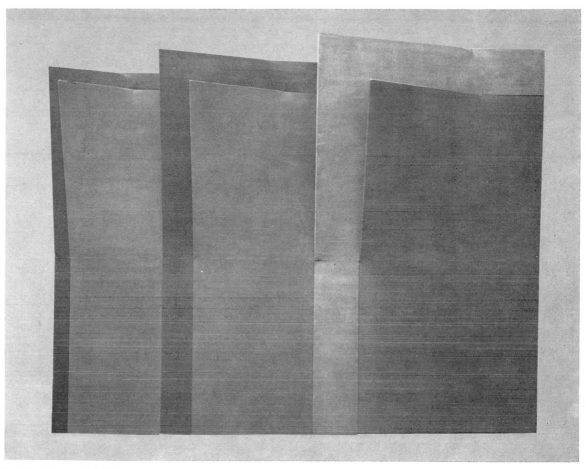

39 Fieldcrest 1969

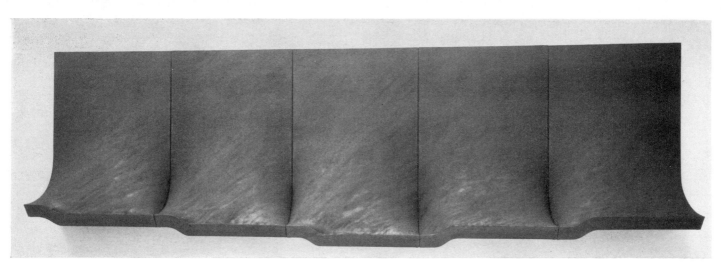

40 Amazone 1969

41 Riverfall 1969

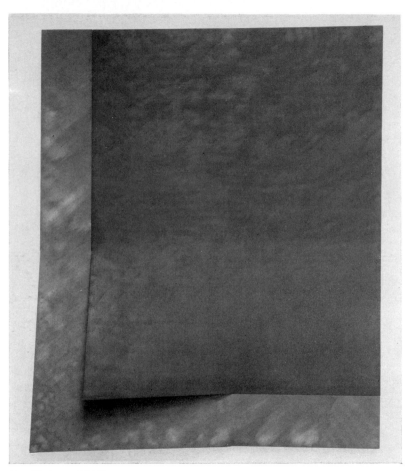

42 Malaya 1969

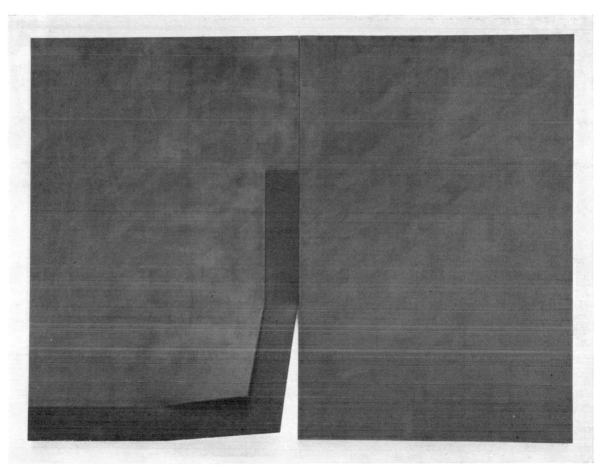

43 Rustle 1969

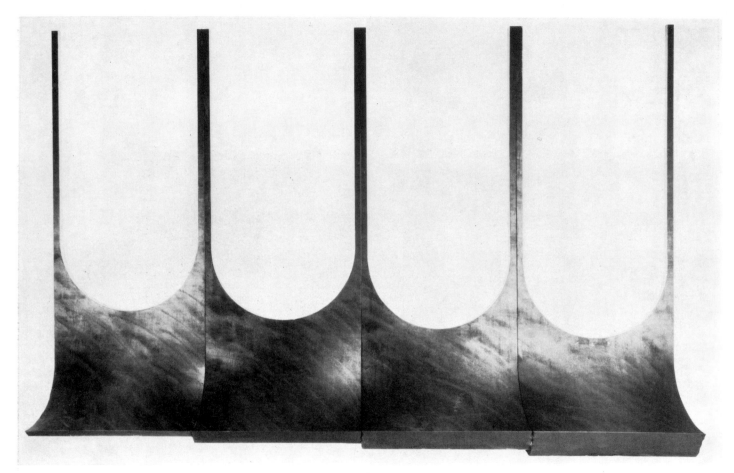

44 Fool's Blue 1970

Arnolfini Gallery 1970

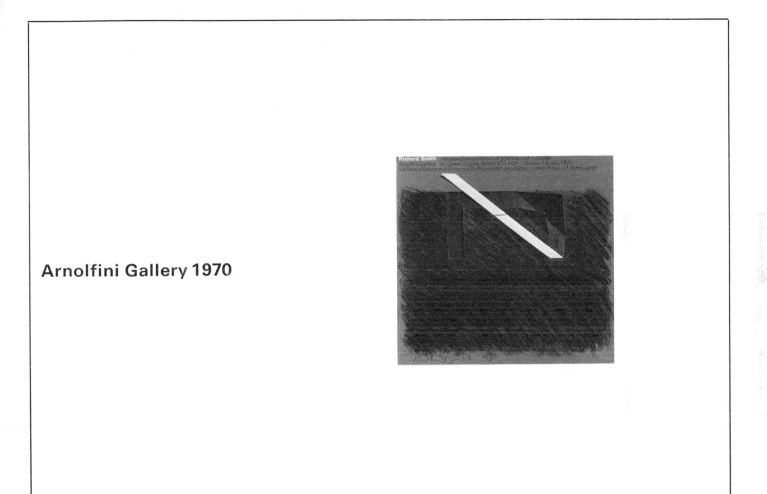

Kasmin Gallery 1971

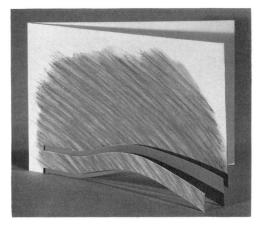

Drawings 1969-72

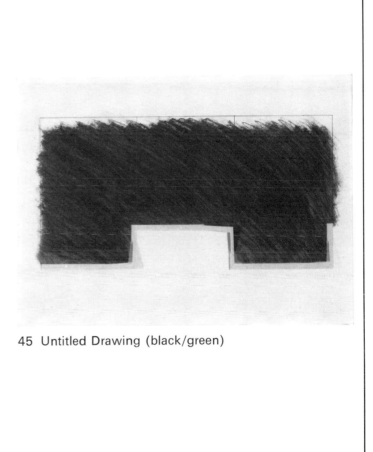

45 Untitled Drawing (black/green)

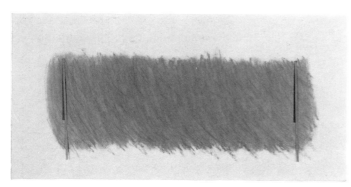

46 MR 1970

47 Untitled Drawing (large brown) 1970

48 Untitled Drawing (black/red) 1970

49 Untitled 1970

50 Large Pink Drawing 1970

51 Large Green Drawing 1970

52 Drawing (green with three tongues) 1970

53 Drawing (black) 1970

54 Drawing (black with 4 colours) 1970

55 Appia II 1971

56 Butterfly Drawing 1971

57 Drawing with graphite 1971

58 Lattice I 1971

59 Drawing (red and green knots) 1972

Galleria dell' Ariete 1972

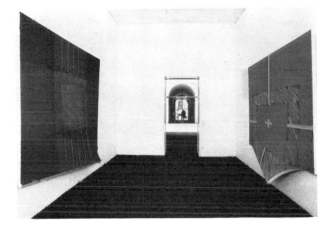

**Museum of Modern Art
Oxford 1972**

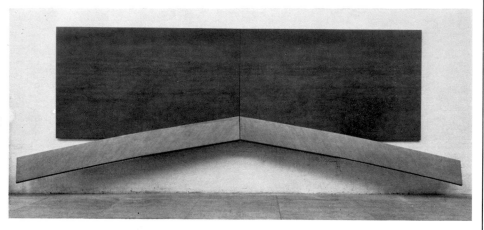

Kasmin Gallery 1972

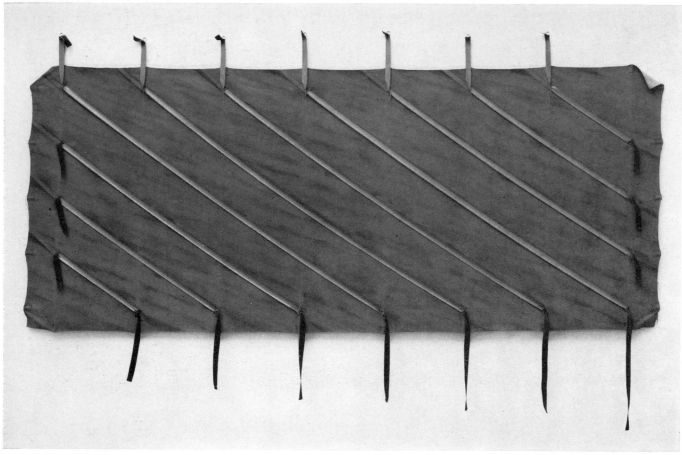

60 Early Reply 1972

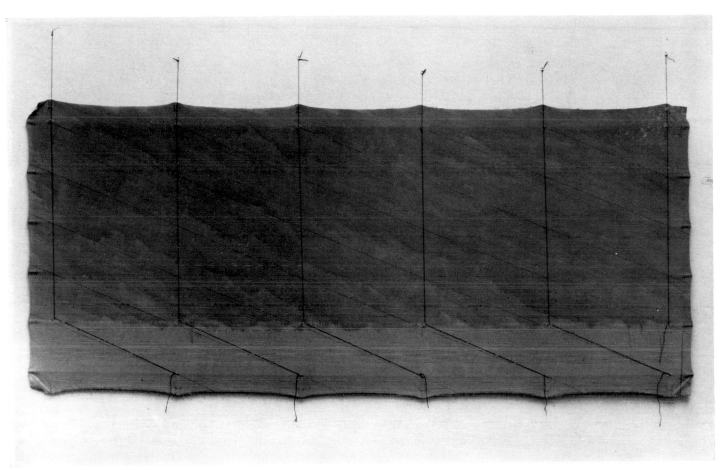

61 First Birthday 1972

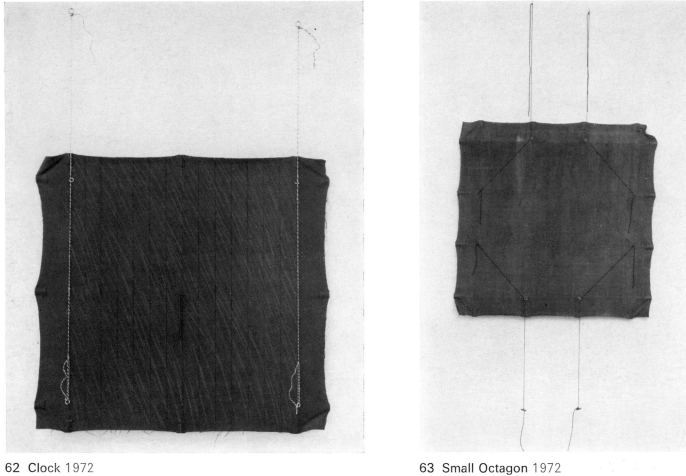

62 Clock 1972

63 Small Octagon 1972

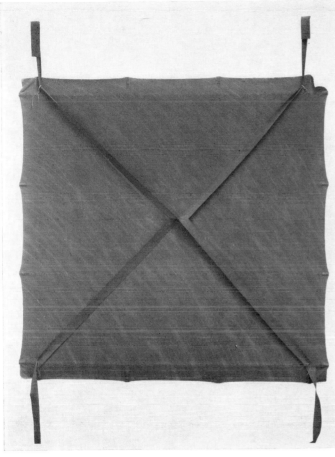

64 Long Cross 1972

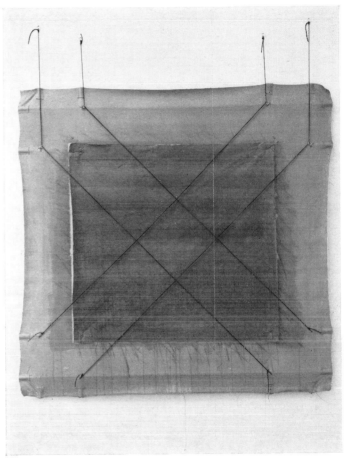

65 Maczone 1972

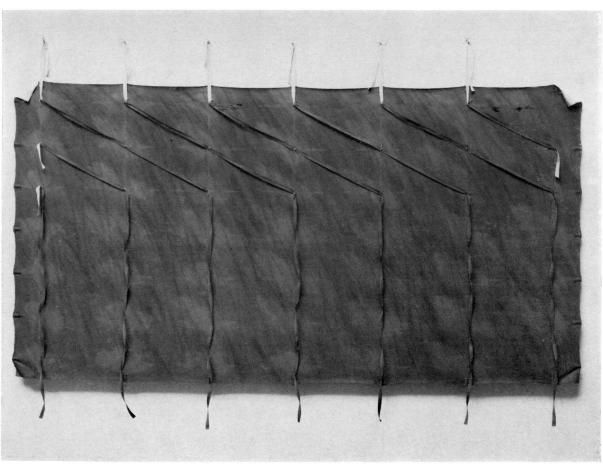

66 Sudden Country 1972

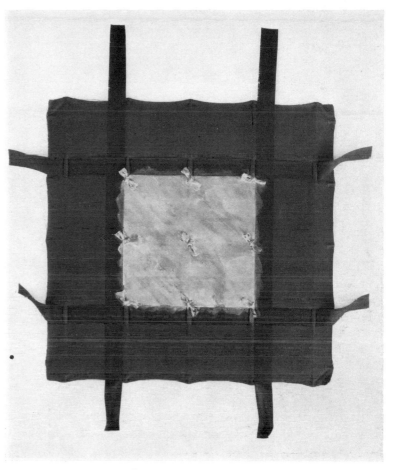

67 Yellow Board 1972

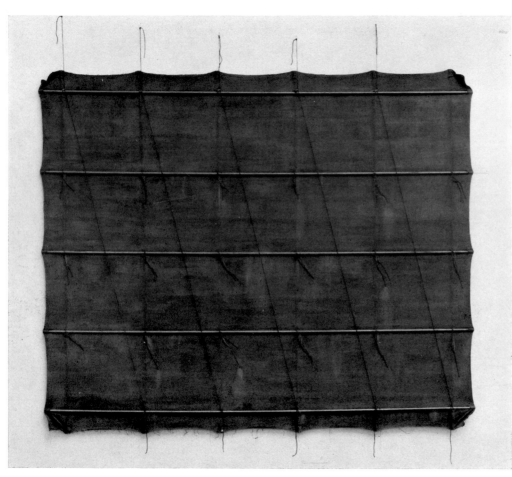

68 Livorno 1972

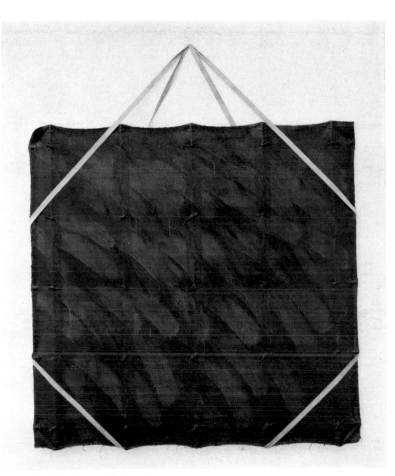

69 Untitled (Blue) 1972

Garage 1973

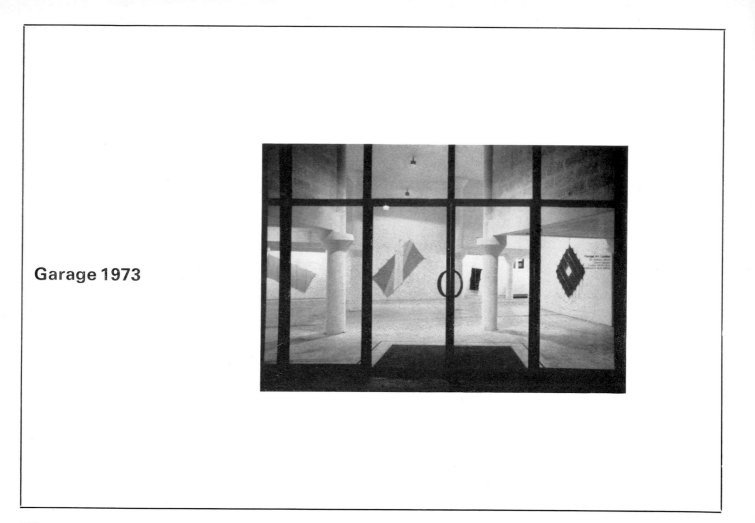

Hayward Gallery 1973
(commission for Mr Chow's restaurant, LA)

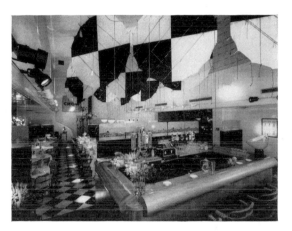

O_K Harris Gallery 1974

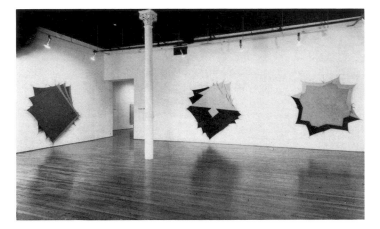

Fundación Museo de Arte Contemporáneo, Caracas, Venezuela 1975

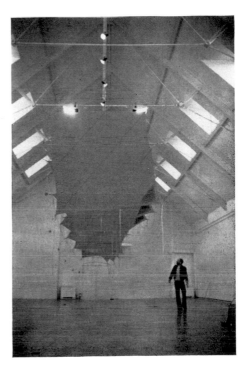

Tate Gallery 1975

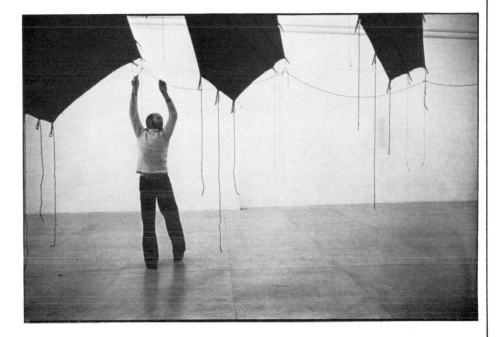

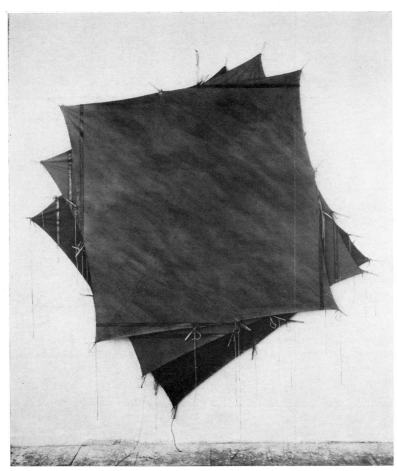

70 Threesquare **2** 1975

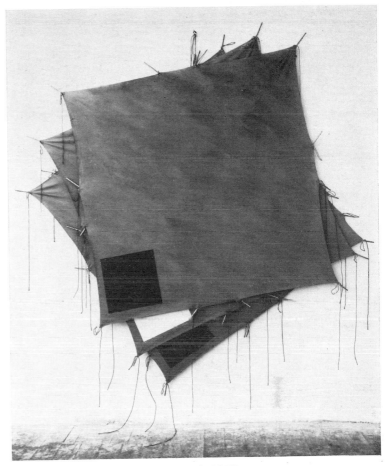

71 Threesquare 3 (Pink Russian) 1975

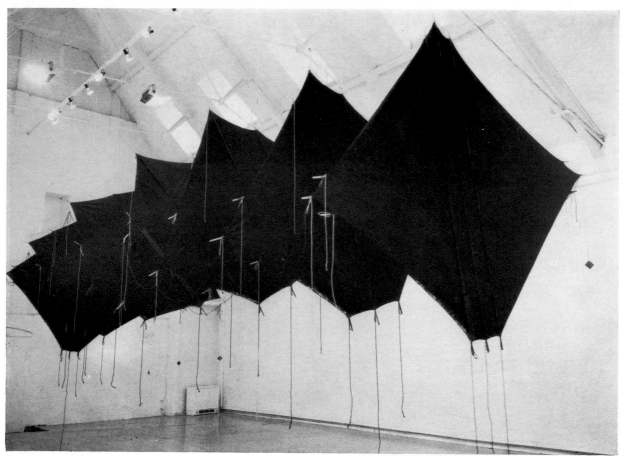

72 The Shuttle 1975

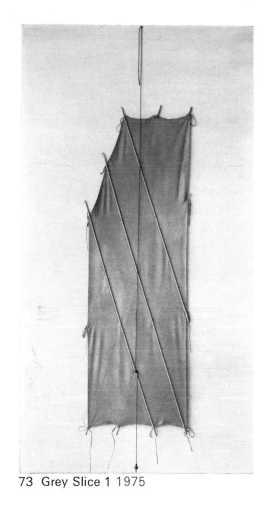

73 Grey Slice 1 1975

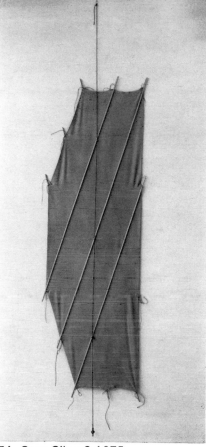

74 Grey Slice 2 1975

117

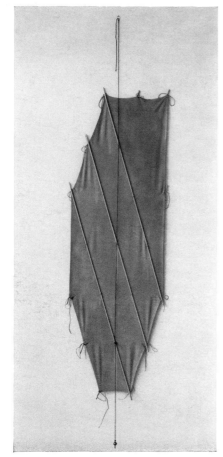

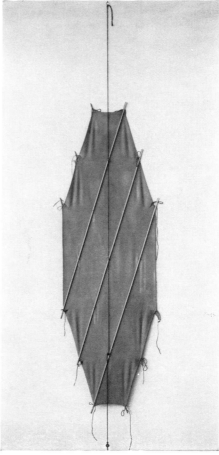

75 Grey Slice 3 1975

76 Grey Slice 4 1975

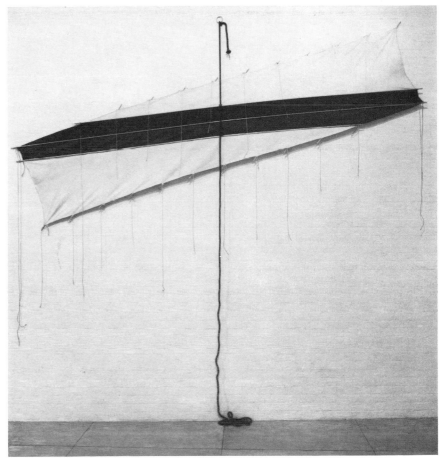

77 Big T 1975

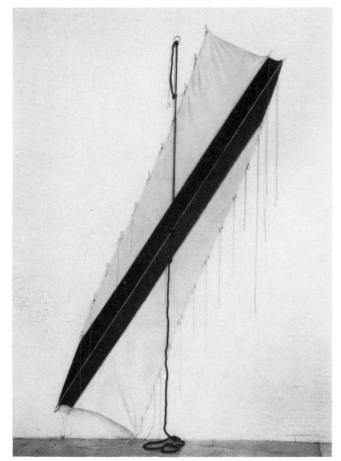

78 Bix X 1975

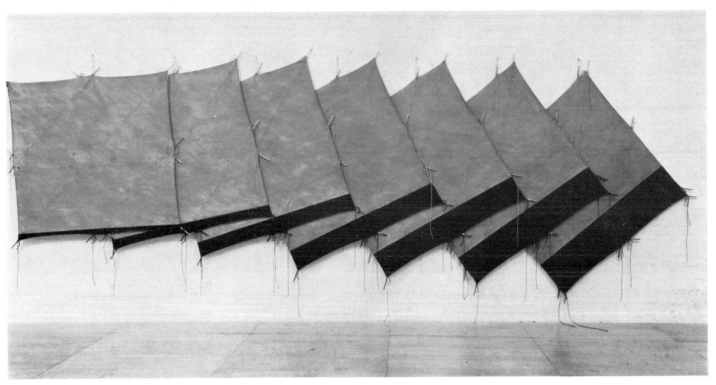

79 Diary 1975

Richard Smith
Seven Exhibitions
1961 – 75

All works belong to the artist
unless otherwise stated

Green Gallery 1961

1
After Six 1960
Oil on canvas
84×86in/214×218.5cm
Kasmin Limited, London

2
Penny 1960
Oil on canvas
89×83in/226×211cm
Ulster Museum, Belfast

3
Formal Giant 1960
Oil on canvas
84×84in/213.5×213.5cm
Mr and Mrs Robert A Rowan,
Los Angeles

4
Somoroff 1960
Oil on canvas
66×60in/168×152cm
Blue Cross Blue Shield, Chicago

5
McCalls 1960
Oil on canvas
90×90in/228.5×228.5cm
Richard Brown Baker Collection,
New York

6
Chase Manhattan 1961
Oil on canvas
84×90in/213.4×228.6cm
Hirshhorn Museum and Sculpture
Garden, Smithsonian Institution

7
Revlon 1961
Oil on canvas
72×90in/183×230cm
Betsy Smith

8
Billboard 1961
Oil on canvas
90×72in/230×183cm
Edward Smith

9
Panatella 1961
Oil on canvas
90×120in/229×305cm
Tate Gallery

10
Capsule 1961
Oil on canvas
84×87in/214×221cm
Philadelphia Museum of Art.
Given by the Woodward Foundation

Kasmin Gallery 1963

11
Pagoda 1963
Oil on canvas
84×114in/214×290cm
Harry Smith

12
Staggerlee 1963
Oil on canvas
89×89in/226×226cm
Peter Stuyvesant Foundation

13
Surfacing 1963
Oil on canvas
35×54×22in/89×137×56cm
McCrory Corporation, New York

14
Gift Wrap 1963
Oil on canvas
80×208×33in/203×520×04cm
Peter Stuyvesant Foundation

15
Lonely Surfer 1963
Oil on canvas
84×60×4in/214×152×10cm
Calouste Gulbenkian Foundation

16
Re-Place 1963
Oil on canvas
53×71×86in/135×180×218cm
Mrs Robert B. Mayer, Chicago

17
Fleetwood 1963
Oil on canvas
108×108in/275×275cm
Lilian Somerville, London

18
Piano 1963
Oil on canvas
70×110×44in/178×280×112cm

Kasmin Gallery 1967

19
A Whole Year a half a day I 1966
Acrylic on canvas
61×61×12in/155×155×30cm
Waddington Galleries, London

20
A Whole Year a half a day II 1966
Acrylic on canvas
61×61×12in/155×155×30cm
Peter Moores, London

21
A Whole Year a half a day III 1966
Acrylic on canvas
61×61×12in/155×155×30cm

22
A Whole Year a half a day IV 1966
Acrylic on canvas
61×61×12in/155×155×30cm
Kasmin Limited, London

23
A Whole Year a half a day V 1966
Acrylic on canvas
61×61×12in/155×155×30cm
Power Gallery of Contemporary Art,
The University of Sydney

24
A Whole Year a half a day VI 1966
Acrylic on canvas
61×61×12in/155×155×30cm
Waddington Galleries, London

25
A Whole Year a half a day VII 1966
Acrylic on canvas
61×61×12in/155×155×30cm
Mrs Robinson Ingalls, Cleveland, Ohio

26
A Whole Year a half a day VIII 1966
Acrylic on canvas
61×61×12in/155×155×30cm
Waddington Galleries, London

27
A Whole Year a half a day IX 1966
Acrylic on canvas
61×61×12in/155×155×30cm

28
A Whole Year a half a day X 1966
Acrylic on canvas
61×61×12in/155×155×30cm
Dr and Mrs R. J. Fusillo, Atlanta, Ga.

29
A Whole Year a half a day XI 1966
Acrylic on canvas
61×61×12in/155×155×30cm

30
A Whole Year a half a day XII 1966
Acrylic on canvas
61×61×12in/155×155×30cm

31
Clairol Wall 1967
Acrylic on canvas
95½×383½×36in/243×975×91cm
Galerie Denise René Hans Mayer,
Düsseldorf

32
Western Stile 1968
Polyurethane on canvas
71×71×12in/180×180×30cm
George Heinrichs, Berlin

33
True North 1968
Polyurethane on canvas
71×71×12in/180×180×30cm
George Heinrichs, Berlin

34
East Gate 1968
Polyurethane on canvas
71×71×12in/180×180×30cm
Castelli, Milan

35
Southern Limit 1968
Polyurethane on canvas
71×71×12in/180×180×30cm
Ennio Brion, Milan

36
Plum Meridian 1968
Polyurethane on canvas
59×177×19¾in/150×450×50cm
Galleria dell' Ariete, Milan

37
First Half 1968
Polyurethane on canvas
71×35×14in/180×90×35cm
Giuseppe Agrati, Veduggio

Kasmin Gallery 1969

38
Passerby 1969
Acrylic and polyurethane on canvas
66×110×12in/168×280×30cm
Granada Television Limited

39
Fieldcrest 1969
Oil and polyurethane on canvas
75×96×12in/190×244×30cm
Kasmin Limited, London

40
Amazone 1969
Oil and polyurethane on canvas
54×179½×11¾in/137×457×30cm
James Dugdale, London

41
Riverfall 1969
Oil and polyurethane on canvas
90×270×14in/228×686×35.5cm
Tate Gallery

42
Malaya 1969
Oil and polyurethane on canvas
96×66×14in/243×198×35cm
Max Gordon, London

43
Rustle 1969
Oil and polyurethane on canvas
72×96×12in/183×244×30cm
British Council, London

44
Fool's Blue 1970
Acrylic and graphite on canvas
131×200×21in/333×508×53cm
Private Collection

Drawings 1969-1972

45
Untitled Drawing (black/green) 1969
Oil pastel and pencil
23¼×30¼in/59×77cm
Kasmin Limited, London

46
MR 1970
Oil pastel and pencil
30×60¼in/76×153cm
Kasmin Limited, London

47
Untitled Drawing (large brown) 1970
Oil pastel and pencil
36×54½in/91.5×138.5cm
John Kasmin, London

48
Untitled Drawing (black/red) 1970
Oil pastel and pencil
23×30¼in/58.5×77cm
Private Collection

49
Untitled 1970
Oil pastel and pencil
21¼×30½in/59×77cm
Bernard Jacobson Limited, London

50
Large Pink Drawing 1970
Oil pastel and pencil
39½×57in/100×150cm
Betsy Smith

51
Large Green Drawing 1970
Oil pastel and pencil
$39 \times 56\frac{1}{2}$in/99×143.5cm
Bernard Jacobson Limited, London

52
Drawing (green with three tongues)
1970
Oil pastel and pencil
$38\frac{1}{4} \times 55$in/97×140cm
Bernard Jacobson Limited, London

53
Drawing (black) 1970
Oil pastel and pencil
$38\frac{1}{4} \times 59\frac{1}{2}$in/$97 \times 151$cm
Waddington Galleries, London

54
Drawing (black with 4 colours) 1970
Oil pastel and pencil
$22\frac{1}{2} \times 30$in/57×76cm
Waddington Galleries, London

55
Appia II 1971
Oil pastel and pencil
$23\frac{1}{4} \times 30\frac{1}{4}$in/$59 \times 77$cm
Kasmin Limited, London

56
Butterfly Drawing 1971
Oil pastel and pencil
23×60in/58.5×152.5cm
Mr and Mrs K. Anschel, London

57
Drawing with graphite 1971
Oil pastel and pencil
$37 \times 40\frac{1}{4}$in/79×102cm

58
Lattice I 1971
Oil pastel and pencil
$22\frac{3}{4} \times 30\frac{1}{4}$in/$58 \times 77$cm
Michael Chow, London

59
Drawing (red and green knots) 1972
Oil pastel and pencil
$27\frac{1}{2} \times 45$in/70×104cm

60
Early Reply 1972
Acrylic on canvas
$53\frac{1}{2} \times 117$in/136×297cm
Waddington Galleries, London

61
First Birthday 1972
Acrylic on canvas
$65\frac{1}{2} \times 118\frac{1}{2}$in/$165 \times 301$cm
Michael D. Abrams, London

62
Clock 1972
Acrylic on canvas
$34 \times 36\frac{3}{4}$in/86×92

63
Small Octagon 1972
Acrylic on canvas
$37\frac{1}{2} \times 37\frac{3}{4}$in/$95 \times 96$cm

64
Long Cross 1972
Acrylic on canvas
79×67in/195×170cm
Kasmin Limited, London

65
Maczone 1972
Acrylic on canvas
$53\frac{1}{2} \times 43\frac{1}{4}$in/$136 \times 110$cm
The Marquess of Dufferin and Ava,
London

66
Sudden Country 1972
Acrylic on canvas
80 × 122in/203 × 310cm
Alistair McAlpine ; on loan to the
National Museum of Wales, Cardiff

67
Yellow Board 1972
Acrylic on canvas
68 × 50½in/173 × 128cm
Michael D. Abrams, London

68
Livorno 1972
Acrylic on canvas
78 × 84in/198 × 214cm
Arts Council of Great Britain

69
Untitled (Blue) 1972
Acrylic on canvas
61 × 48in/155 × 122cm
Private Collection

70
Threesquare 2 1975
Acrylic on canvas
3 pieces each 69 × 69in/175 × 175cm
Gimpel Fils, London

71
Threesquare 3 (Pink Russian) 1975
Acrylic on canvas
3 pieces each 69 × 69in/175 × 175cm

72
The Shuttle 1975
Acrylic on canvas
7 pieces each 69 × 69in/175 × 175cm

73
Grey Slice 1 1975
Acrylic on canvas
88½ × 29½in/225 × 75cm

74
Grey Slice 2 1975
Acrylic on canvas
88½ × 29½in/225 × 75cm

75
Grey Slice 3 1975
Acrylic on canvas
88½ × 29½/225 × 75cm

76
Grey Slice 4 1975
Acrylic on canvas
88½ × 29½/225 × 75cm

77
Big T 1975
Acrylic on canvas
31½ × 143½/80 × 365cm

78
Bix X 1975
Acrylic on canvas
31½ × 143½in/80 × 365cm

79
Diary 1975
Acrylic on canvas
7 pieces each 59 × 59in/150 × 150cm

Richard Smith

Biography

1931
Born in Letchworth, Hertfordshire

1948-50
Studied at Luton School of Art, Luton

1950-52
Served in the Royal Air Force, Hong Kong

1952-54
Studied at St. Albans School of Art

1954-57
Studied at the Royal College of Art, London

1957
Awarded the Royal College of Art Scholarship for travel in Italy

1957-58
Taught mural decoration at Hammersmith College of Art, London

1959
Awarded the Harkness Fellowship of the Commonwealth Fund for travel in the U.S.A. and spent the following two years in the U.S.A.

1961-63
Taught at St. Martin's School of Art, London

1963-65
Lived and worked in New York

1964
Married Betsy Scherman

1965
Taught at Aspen, Colorado

1966
Awarded the Mr and Mrs Robert C. Scull Award, 33rd Venice Biennale
First son, Edward, born

1967
Awarded the Grand Prize, IX São Paulo Bienal, Brazil
Taught at the University of Virginia, Charlottesville, U.S.A.

1968
Taught at the University of California, Irvine Campus
Moved to East Tytherton, Wiltshire

1970
Second son, Harry, born

1971
Awarded the C.B.E.

One-Man Exhibitions

1961
Green Gallery, New York City

1962
Artist's studio, Bath Street, London
Institute of Contemporary Arts, London

1963
Kasmin Gallery, London
Green Gallery, New York City

1965
Green Gallery, New York City

1966
Whitechapel Gallery, London
Richard Feigen Gallery, New York City
Series of screenprints for Editions Alecto

1967
Kasmin Gallery, London
University of Virginia, Charlottesville, Va.
Richard Feigen Gallery, New York City
IX São Paulo Bienal, Brazil

1968
Richard Feigen Gallery, New York City

1969
Galleria dell'Ariete, Milan
Kasmin Gallery, London

1970
Arnolfini Gallery, Bristol
35th Venice Biennale, Venice, British Pavilion

1971
Richard Feigen Gallery, New York City
Kasmin Gallery, London

1972
Galleria dell'Ariete, Milan
Museum of Modern Art, Oxford
Bear Lane Gallery, Oxford
Kasmin Gallery, London

1973
Ruth S. Schaffner Gallery, Santa Barbara
Garage Art, London
Waddington Gallery (Graphics)

1974
O. K. Harris, New York
Galerie Swart, Amsterdam

1975
'Paginas Amarillas', Museo de Arte Contemporáneo de Caracas, Venezuela.
Kettles Yard Gallery, Cambridge
Gimpel Fils Gallery, London

Group Exhibitions

1954
'Young Contemporaries,' RBA Galleries, London

1957
'Six Young Contemporaries,' Gimpel Fils Gallery, London
'Dimensions,' O'Hana Gallery, London
'New Trends in British Art,' Rome (New York Art Foundation, Rome)

1958
'Abstract Impressionism,' Arts Council Gallery, Carlisle
John Moores Liverpool Exhibition, Walker Art Gallery, Liverpool

1959
'Place, A Collaboration', I.C.A., London

1960
'Situation,' RBA Galleries, London

1961
'Deuxième Biennale de Paris,' Musée d'Art Moderne, Paris
'New London Situation,' New London Gallery, London

1961-62
'The 1961 Pittsburgh International Exhibition of Contemporary Paintings & Sculpture,' Carnegie Institute, Pittsburgh, Pennsylvania

1962
'Contemporary Painting,' Yale University, New Haven, Connecticut
'Kompas II,' Stedelijk Museum, Eindhoven, Holland
'Towards Art ?,' Royal College of Art, London and subsequent Arts Council tour

1962-63
'British Art Today,' San Francisco Museum of Art and also Dallas Museum of Contemporary Art, Santa Barbara Museum of Art

1963
'VII Tokyo Biennial,' Tokyo Metropolitan Art Gallery, Tokyo and subsequent tour of Japan.
'Critic's Choice,' Stone Gallery, Newcastle
'British Painting in the Sixties,' Whitechapel Gallery, London
'Dunn International,' Tate Gallery, London
John Moores Liverpool Exhibition, Walker Art Gallery, Liverpool
'118 Show,' Kasmin Gallery, London

1964
'Englische Kunst der Gegenwart,' Stadtische Kunstgalerie, Bochum, Germany
'Britische Malerie der Gegenwart,' Kunsthalle, Düsseldorf
'Painting and Sculpture of a decade,' Tate Gallery, London
'Nieuwe Realisten,' Gemeente Museum, The Hague
'Premio Marzotto,' Valdagno, Italy and subsequent European tour
'The Shaped Canvas,' The Solomon R. Guggenheim Museum, New York
'Pop Etc.,'' Museum des 20 Jahrhunderts Vienna
Group Show. Kasmin Gallery, London

1964-65
'Neue Realisten & Pop Art,' Akademie de Kunste, Berlin

1965
'Pop Art, Nouveau Réalisme,' Palais des Beaux Arts, Brussels
'Biennale des Jeunes,' Musée d'Art Moderne, Paris
'Invitational International Prize Competition,' Instituto Torcuato di Tella, Buenos Aires, Argentina
John Moores Liverpool Exhibition, Walker Art Gallery, Liverpool
'118 Show,' Kasmin Gallery, London
'The English Eye,' Marlborough-Gerson Gallery, New York

1965-66
'London : The New Scene,' Walker Art Center, Minneapolis, Minnesota and subsequent tour to Washington D.C., Boston, Seattle, Vancouver, Toronto, and Ottawa

1966
'XXXIII Venice Biennale,' Venice and subsequent tour to Berne, Brussels, and Rotterdam
'The Other Tradition,' The Institute of Contemporary Art, Pittsburgh, Pa.
'26th Annual Exhibition by the Society for Contemporary Art,' I.C.A., Chicago, Illinois
'Aspects of British Art,' Auckland City Art Gallery, New Zealand, and tour of New Zealand and Australia
'Four Englishmen,' Galleria dell'Ariete, Milan
'Caro, Cohen, Denny, Smith,' Kasmin Gallery, London

1966-67
'New Shapes of Colour,' Stedelijk Museum, Amsterdam, and also Berne, Stuttgart

1967
'Nuovo Techniche d'Imagine,' San Marino, Italy

1967
Selected works from the collection of Mr and Mrs Gates Lloyd, I.C.A., University of Pennsylvania, Philadelphia
'Environment 1,' Architectural League of New York, New York
'Color, Image, and Form,' Detroit Institute of the Arts, Detroit, Michigan
'The 1967 Pittsburgh International Exhibition of Contemporary Painting & Sculpture,' Carnegie Institute, Pittsburgh, Pennsylvania
'IX Bienal de São Paulo,' São Paulo, Brazil
'Englische Kunst,' Galerie Bischofberger, Zurich
'Jeunes Peintres Anglais,' Palais des Beaux-Arts, Brussels
'Salone Internazionale dei Giovani,' Milan
'Drawing Towards Painting,' Arts Council & tour of England
'118 Show,' Kasmin Gallery, London
'Recent British Painting,' Stuyvesant Foundation, Tate Gallery, London

1967-68
'Annual Exhibition of American Painting,' The Whitney Museum of American Art, New York

1967
Selection from the Collection of Mr & Mrs Robert A. Rowan, University of California, Irvine campus, and San Francisco Museum

1968
'Davis, Irwin, Smith,' Jewish Museum, New York
'Arte Moltiplicata,' Galleria Milano, Italy
Selection from the Collection of Hanford Yang, Aldrich Museum of Contemporary Art, Connecticut
'Contemporary Art Fair,' Palazzo Strozzi, Florence

'Documenta 4,' Kassel, Germany
'Power Bequest Exhibition,' Power Institute of Fine Arts, University of Sydney, Australia
'Junge Generation, Gross Britannien,' Akademie der Kunst, Berlin

1968-69
'British International Print Biennale,' Bradford, Yorkshire
'European Painters Today,' Musée des Arts Decoratifs, Paris ; on tour to Jewish Museum, New York ; National Collection of Fine Arts, Washington, D.C. ; Museum of Contemporary Arts, Chicago ; High Museum of Art, Atlanta, Georgia ; and Dayton Art Institute, Dayton.

1969
'Artists from the Kasmin Gallery,' Arts Council Gallery, Belfast
'Marks on a Canvas,' Museum Am Ostwall, Dortmund

1970
35th Venice Biennale, Venice
The Sebastian de Ferranti Collection, Whitworth Art Gallery, Manchester
'Contemporary British Art' National Museum of Modern Art, Tokyo
'International Exhibition of Contemporary Art,' Carnegie Institute, Pittsburgh, Pa.
'British Paintings and Sculpture, 1960-70', National Gallery of Art, Washington, D.C.

1972
'Contemporary Prints,' Ulster Museum, Belfast

1973
'La Peinture Anglaise Aujourd'hui', Musée d'Art de la Ville de Paris
'Henry Moore to Gilbert and George' Modern British Art from the Tate Gallery, Palais des Beaux-Arts, Brussels

1974
'British Painting '74', Hayward Gallery, London

1975
C.A.S. Art Fair. Mall Galleries

Writings by the Artist

'Ideograms', *Ark,* London, No. 16, 1956, pp. 52-56

With Roger Coleman. 'Film Backgrounds, The City,' *Ark,* London, No. 18, November 1956, pp. 54-56

'Film Backgrounds 2 Sitting in the Middle of To-day,' *Ark,* London, No. 19, 1957, pp. 13-15

'Man and He-Man,' *Ark,* London, No. 20, 1957, pp. 12-16

John Plumb, London, 1957, Text for exhibition catalogue at New Vision Centre Gallery

'Jackson Pollock 1912-1956,' *Art News and Review,* London, Vol. X, No. 22, November 1958, p. 5

With Robyn Denny. 'Ev'ry-which-way, Project for a Film,' *Ark,* London, No. 22, 1959

'That Pink,' *Gazette,* London, No. 2, 1961

'Brief Statement,' *Metro,* Milan, No. 6, 1962, p. 112

'New Readers Start Here,' *Ark,* London, No. 32, Summer 1962, pp. 37-43

'Trailer : Notes Additional to a Film,' *Living Arts,* London, No. 1, Spring 1963, pp. 29-35

'Dialogue with the Artist,' London, May 1966. Exhibition Catalogue, Whitechapel Gallery, London

Statement. Jewish Museum Catalogue, New York, 1958

Text for 'Paginas Amarillas' Exhibition Catalogue, Museo de Arte Contemporáneo de Caracas, Venezuela, 1975

Selected articles and reviews

Hodges, John. 'Collage,' *Ark,* London, No. 17, 1956, pp. 24-29.

Coleman, Roger. 'Two Painters,' *Ark,* London, No. 20, 1957, pp. 23-25

Swenson, Gene R. *Art News,* Vol. 60, No. 4, Summer 1961, p. 16

Alloway, Lawrence. 'Richard Smith,' *Metro,* Milan, No. 6, 1962, pp. 111-113

Fried, Michael. 'London,' *Arts,* Vol. XXXVI, No. 10, September 1962, p. 29

Reichardt, Jasia. 'Richard Smith,' *Arts Review,* London, Vol. XIV, No. 20, October 1962, p. 19

'London Letter, Smith,' *Art International,* Zurich, Vol. VII, No. 1, January 1963, pp. 86-88

Rykwert, Joseph, 'Exhibit at the Institute of Contemporary Arts' *Domus,* Milan, Vol. 398, No. 45, January 1963

Melville, Robert. 'One Man Show at the I.C.A.,' *Architectural Review,* London, Vol. 133, No. 141, February 1963

Rose, Barbara. 'New York Letter,' *Art International,* Zurich, Vol. 7, No. 3, March 25, 1963, pp. 65-66

Sandler, Irving. 'Richard Smith,' *Art News,* Vol. 62, No. 2, April 1963, p. 14

Judd, Donald. 'Richard Smith,' *Arts,* Vol. XXXVII, No. 7, April 1963, p. 59

Rouve, Pierre. 'Smith and Space,' *Arts Review,* London, Vol. XV, No. 22, November 1963, p. 8

Lynton, Norbert. 'London Letter, American Pop Art and Richard Smith,' *Art International,* Lugano, Vol. 8, No. 1, February 1964, pp. 42-43

Lippard, Lucy. 'Richard Smith — Conversations with the Artist,' *Art International,* Lugano, Vol. 8, No. 9, November 25, 1964, pp. 31-34

James, Monte. 'San Francisco,' *Art forum,* Vol. III, No. 7, April, 1965, p. 42

Johnston, Jill. 'Richard Smith,' *Art News,* Vol. 64, No. 5, September 1965

Lucie-Smith, Edward. 'The Elements of Caprice,' *The Studio,* July 1966

Mellow, James R. 'New York Letter,' *Art International,* Lugano, Vol. II, No. 1, January 20, 1967, pp. 63-66

'London : Smith,' *Art International,* Lugano, Vol. XI, No. 4, April 20, 1967, p. 47

Overy, Paul. 'Hint of Mint,' *The Listener,* March 1967

Lucie-Smith, Edward. 'What Ever Happened to British Pop,' *Art and Artists,* May 1967

'Washington and Detroit,' *Studio International,* London, Vol. 174, No. 891, July/August 1967, p. 51

Barrett, Cyril. 'Richard Smith : Sculptor or Painter ?' *Art International,* Lugano, Vol. II, No. 8, October 20, 1967, pp. 35-38

Baro, Gene. 'British Painting : The Post-War Generation,' *Studio International,* London, Vol. 174, No. 893, October 1967, pp. 133-141

Bowness, Alan. 'São Paulo-Impressions of the Bienal,' *Studio International,* November 1967

Finch, Christopher. 'Richard Smith — The Winner of the Grand Prize of the São Paulo Bienal in two shows.' *Arts Magazine,* March 1968

Wasserman, Emily. 'Robert Irwin, Gene Davis, Richard Smith — The Jewish Museum mounts a hard-to-assess 3-man show,' *Artforum,* May 1968

Finch, Christopher. 'Image as Landscape,' *Aspects of British Art 1950-1968*, Pelican Books, 1969, pp. 53-60

Lynton, Norbert. 'Art, Cash and the dropouts,' *The Guardian*, 3 January 1970

'Richard Smith talks to Ann Seymour,' *Art and Artists*, June 1970

Gilmour, Pat. 'Richard Smith printmaker,' *Art and Artists*, June 1970

Seymour, Ann. 'Richard Smith,' *Studio International*, June 1970

'The Biennale,' *Harpers Bazaar*, June 1970

Wolfram, Eddie, 'Richard Smith I.C.A. Gallery,' *Arts Review*, December 1970

Clay, J. 'La Peinture anglaise aujourd'hui : Musée municipal d'art moderne, Paris,' *XXe Siecle*, December 1973

Packer, W. 'Radical and elegant,' *Art and Artists*, March 1974

Zucker, Barbara. 'Richard Smith. O.K. Harris,' *Art News*, Vol. 74, No. 2, February 1975

Greenwood, Michael. 'British Painting 1974,' *Art Canada*, Vol. XXXII, No. 1, March 1975

Exhibition Catalogues

New Trends in British Art, Rome/New York Art Foundation, Rome, December 1957. Text by Sir Herbert Read and Lawrence Alloway.

Dimensions, British Abstract Art, O'Hana Gallery, London, 1957. Text by Lawrence Alloway.

Five Painters, Institute of Contemporary Arts, London, 1958. Text by Roger Coleman.

Place, Institute of Contemporary Arts, London, 1959. Text by Roger Coleman.

Situation, RBA Galleries, London, 1969. Text by Roger Coleman.

Richard Smith, Green Gallery, New York, 1961. Text by Lawrence Alloway.

Grande-Bretagne, Deuxième Biennale de Paris, Musée d'Art Moderne, Paris, 1961. Text by Lawrence Alloway.

British Art Today, San Francisco Museum of Art, San Francisco, 1962, Text by Lawrence Alloway.

Richard Smith, Institute of Contemporary Arts, London, 1962. Text by Roger Coleman.

Kompass II, Contemporary Painting in London, Stedelijk van Abbe-Museum, Eindhoven, Holland, 1962. Text by Ronald Alley.

Nieuwe Realisten, Gemeente Museum, The Hague, 1964.

Britische Malerei der Gegenwart, Kunsthalle, Düsseldorf, Germany, 1964. Text by Ronald Alley.

Englische Kunst der Gegenwart, Stadtische Kunstgalerie, Bochum, Germany, 1964. Text by Sir Roland Penrose and Sir Herbert Read.

London: The New Scene, Walker Art Center, Minneapolis, Minnesota, February 1965. Text by Martin Friedman.

Five Young British Artists, British Pavillion, XXXIII Venice Biennale, June 1966. Organized by the British Council. Text by David Thompson.

Richard Smith, Whitechapel Gallery, London, May 1966. Text by Bryan Robertson and dialogue with the artist.

Grã-Bretanha 1967, IX São Paulo Bienal, São Paulo, Brazil, September 1967. Organized by the British Council. Richard Smith text by Christopher Finch.

Richard Smith, Jewish Museum, New York, 1968. Text by Barbara Rose.
'Marks on a Canvas,' Dortmund, 1969. Text by Ann Seymour.

Richard Smith, Venice Biennale 1970. Organised by the British Council. Text by Ann Seymour.

Richard Smith, Retrospective Exhibition of graphics and multiples. Arnolfini Gallery, Bristol, 1970

'Paginas Amarillas.' Museo de Arte Contemporáneo de Caracas, Venezuela, 1975. Text by Richard Smith.

Cut, folded and tied. Organised by the Arts Council, 1975. Text by Linda Morris.

List of Lenders

Michael D. Abrams	61, 67
Giuseppe Agrati	37
Mr and Mrs K. Anschel	56
Arts Council of Great Britain	68
Richard Brown Baker	5
Ennio Brion	35
Castelli	34
Michael Chow	58
Blue Cross Blue Shield	4
British Council	43
Calouste Gulbenkian Foundation	15
The Marquess of Dufferin and Ava	65
James Dugdale	40
Dr and Mrs J. Fusillo	28
Galerie Denise René Hans Mayer	31
Galleria dell'Ariete	36
Gimpel Fils	70
Max Gordon	42
Granada Television	38
George Heinrichs	32, 33
Hirshhorn Museum and Sculpture Garden, Smithsonian Institution	6
Bernard Jacobson Ltd	49, 51, 52
Mrs Robinson Ingalls	25
John Kasmin	47
Kasmin Limited	1, 22, 39, 45, 46, 55, 64
Mrs Robert B. Mayer	16
Alistair McAlpine	66
McCrory Corporation	13
Peter Moores	20
Philadelphia Museum of Art	10
Power Gallery of Contemporary Art, The University of Sydney	23
Private Collection	44, 48, 69
Mr and Mrs Robert A. Rowan	3
Betsy Smith	7, 50
Edward Smith	8
Harry Smith	11
Lilian Somerville	17
Peter Stuyvesant Foundation	12, 14
Tate Gallery	9, 41
Ulster Museum	2
Waddington Galleries	19, 24, 26, 53, 54, 60, 62

Photographic credits

Rudolph Burckhardt	10
A. C. Cooper	1, 2, 11-16, 18, 30, 34-37
Prudence Cuming Associates Ltd.	38-44, 60-69
David Nye and Michael Duffet	8, 9, 19, 24, 26, 29, 45-59
Rowland Scherman	70-79
Frank J. Thomas	3
R. Todd White	21
John Webb	7, 20, 22, 23, 27